WF STUDIO

fashion design
WORKSHOP:
Remix

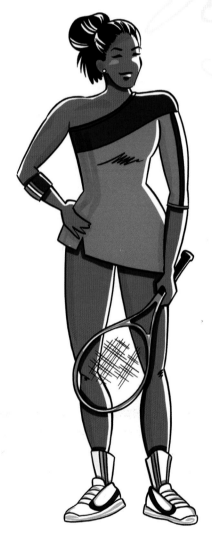

Stephanie Corfee

Walter Foster

Brimming with creative inspiration, how-to projects, and useful information to enrich your everyday life, Quarto Knows is a favorite destination for those pursuing their interests and passions. Visit our site and dig deeper with our books into your area of interest: Quarto Creates, Quarto Cooks, Quarto Homes, Quarto Lives, Quarto Drives, Quarto Explores, Quarto Gifts, or Quarto Kids.

© 2020 Quarto Publishing Group USA Inc.
Artwork and text © 2020 Stephanie Corfee

First published in 2020 by Walter Foster Publishing, an imprint of The Quarto Group. 26391 Crown Valley Parkway, Suite 220, Mission Viejo, CA 92691, USA.
T (949) 380-7510 **F** (949) 380-7575 **www.QuartoKnows.com**

Walter Foster Publishing titles are also available at discount for retail, wholesale, promotional, and bulk purchase. For details, contact the Special Sales Manager by email at specialsales@quarto.com or by mail at The Quarto Group, Attn: Special Sales Manager, 100 Cummings Center, Suite 265D, Beverly, MA 01915, USA.

ISBN: 978-1-63322-828-3

Digital edition published in 2020
eISBN: 978-1-63322-829-0

Printed in Malaysia
10 9 8 7 6 5 4 3 2 1

Table of Contents

Introduction

Welcome to *Fashion Design Workshop: REMIX*—where fashion design, illustration, and creativity intersect with inclusivity, empowerment, and individuality! In this companion to my first book, *Fashion Design Workshop* (Walter Foster Publishing), we dive deeper into creative expression through learning the art of fashion design, including experimenting with a range fun and engaging techniques across a variety of media, while simultaneously learning to cultivate a uniquely personal style. *Fashion Design Workshop: REMIX* is a celebration of design and how we express ourselves through fashion regardless of body type, physical ability, or gender.

In this book, aspiring fashion designers, trendsetters, and style gurus are invited to explore a wide variety of tools and materials that can be used to illustrate and design a range of fashions—from fancy dresses and red carpet-worthy looks to sportswear and chic urban outfits. Using graphite pencils, pens, and markers, as well as watercolor paint, metallic paint pens, and even collage, fashionistas of all backgrounds will embrace the creativity that comes with trying different types of mixed media to create fashions that run the range from classic and conventional to wild and whimsical. Try all of the suggested tools to learn what works best for you and your personal style—be it traditional drawing methods or digital illustration tools.

In Chapter 1, you'll learn everything you need to get started, including how to work with the various featured art tools, as well as basic drawing and sketching techniques. Chapter 2 includes a comprehensive quiz for uncovering your personal style and then goes into greater detail for using myriad art techniques to suit every style and design theme.

In Chapters 3, 4, and 5, you'll begin putting your knowledge into practice by following step-by-step projects that demonstrate how to create a range of designs inspired by pop culture and contemporary fashion. In Chapter 6, you'll learn how to create your own uniquely themed fashion line, while the last four pages of the book include templates in varying shapes and sizes, which you can scan or photocopy to use over and over again.

Whether you are an experienced fashionista or just starting out for the first time, you're sure to find creative design ideas, inspiration, and a plethora of art tips and techniques for taking your fashion illustration game to the next level!

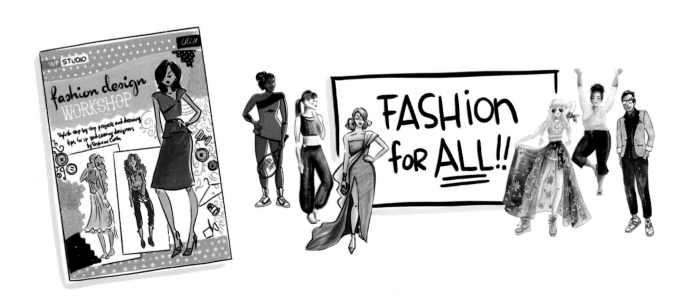

Getting Started

Tools & Materials

Sketchpad or Loose Drawing Paper. Keep a variety of sketchpads or notebooks on hand in various sizes. Jot quick sketches on smaller pages; then work out your ideas on larger sheets. Be sure to use heavier papers with any wet media, such as marker or watercolor, to prevent warping.

Graphite Pencils. Any pencil will do, but you may prefer a mechanical pencil because the leads stay sharp and produce a consistent line thickness.

Colored Pencils. Colored pencils are a convenient and easy method to add color. Professional-grade colored pencils have a waxy, soft lead that is excellent for shading and building up layers of color. Watercolor pencils are another excellent choice for adding touches of color to your artwork.

Tip! Whenever possible, try to purchase the best-quality art tools that you can afford. High-quality pencils really do make a difference to the final outcome! They have more pigment and richer color, and they layer easily.

Pastel Pencils. Pastel pencils are exactly what they sound like: traditional soft pastels encased in a wooden barrel. They draw like pencils and can be sharpened using a regular pencil sharpener. They have a slightly chalkier texture than traditional colored pencils and can be used to layer and blend colors.

Kneaded Eraser. These pliable erasers can be shaped to a point for precision. They never wear down, and they don't leave eraser dust behind. They are also very gentle on paper.

Markers. Transparent water-based markers are available in a wide variety of styles. They are great for laying down large areas of vibrant color, and they also allow for layering and blending, which comes in handy for rendering sheer fabrics.

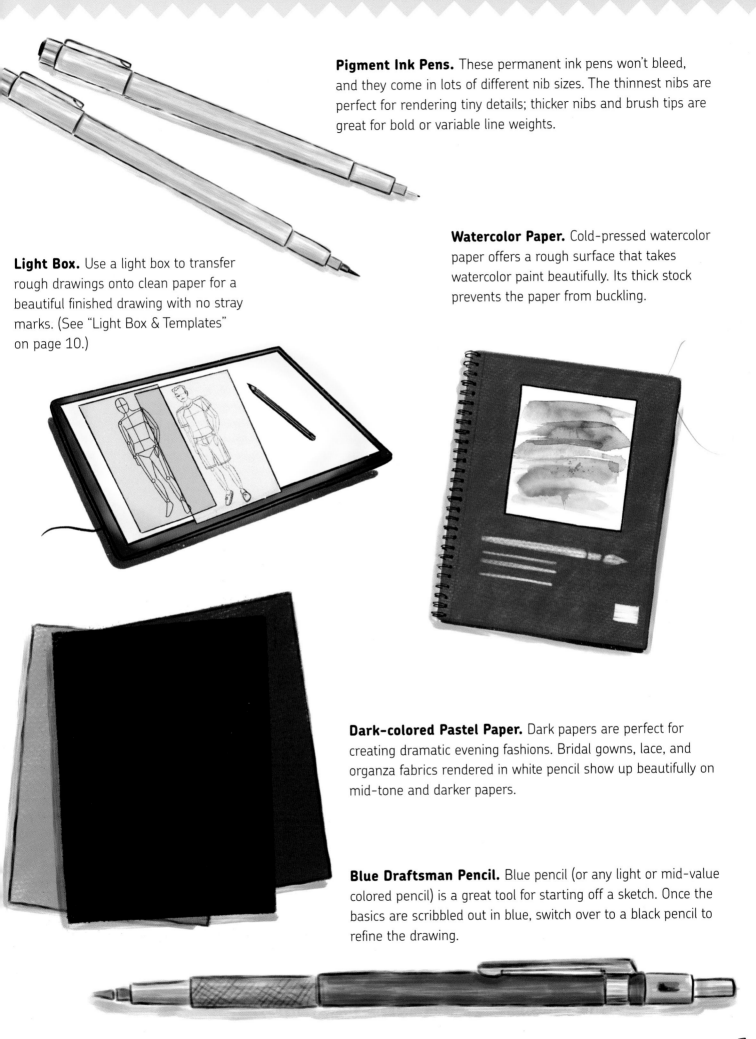

Pigment Ink Pens. These permanent ink pens won't bleed, and they come in lots of different nib sizes. The thinnest nibs are perfect for rendering tiny details; thicker nibs and brush tips are great for bold or variable line weights.

Light Box. Use a light box to transfer rough drawings onto clean paper for a beautiful finished drawing with no stray marks. (See "Light Box & Templates" on page 10.)

Watercolor Paper. Cold-pressed watercolor paper offers a rough surface that takes watercolor paint beautifully. Its thick stock prevents the paper from buckling.

Dark-colored Pastel Paper. Dark papers are perfect for creating dramatic evening fashions. Bridal gowns, lace, and organza fabrics rendered in white pencil show up beautifully on mid-tone and darker papers.

Blue Draftsman Pencil. Blue pencil (or any light or mid-value colored pencil) is a great tool for starting off a sketch. Once the basics are scribbled out in blue, switch over to a black pencil to refine the drawing.

Watercolor Paint. Watercolor is an excellent option for coloring your designs. Use watercolor to build up vibrancy, create textures and blooming effects, and mix shades.

Watercolor Paintbrushes. Watercolor brushes are specifically made to hold water-based pigments. They come in a variety of sizes for broad washes and small details.

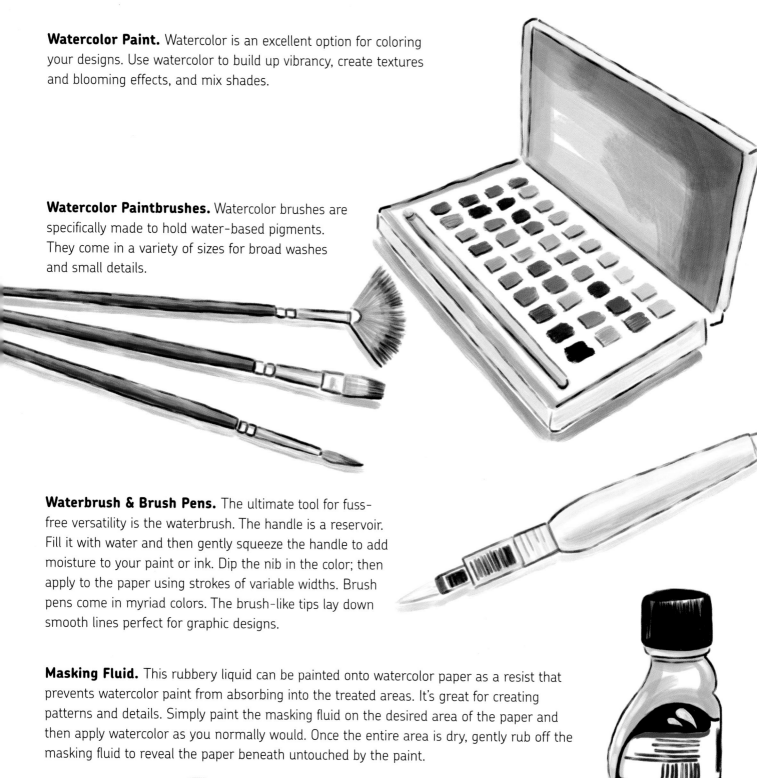

Waterbrush & Brush Pens. The ultimate tool for fuss-free versatility is the waterbrush. The handle is a reservoir. Fill it with water and then gently squeeze the handle to add moisture to your paint or ink. Dip the nib in the color; then apply to the paper using strokes of variable widths. Brush pens come in myriad colors. The brush-like tips lay down smooth lines perfect for graphic designs.

Masking Fluid. This rubbery liquid can be painted onto watercolor paper as a resist that prevents watercolor paint from absorbing into the treated areas. It's great for creating patterns and details. Simply paint the masking fluid on the desired area of the paper and then apply watercolor as you normally would. Once the entire area is dry, gently rub off the masking fluid to reveal the paper beneath untouched by the paint.

Washi Tape. Use bits of patterned washi tape for metallic accents, dotted bags, hair scarves, patchwork, or other creative designs. It comes in a variety of patterns and finishes, and its adhesive back makes applying it a breeze.

Metallic Paint Pens. Add gold, copper, or silver sparkle to any design with this easy-to-use tool. Nothing captures the gleam quite as well, plus metallic paint pens can be applied over nearly any other media.

Gel Pens. Opaque details are easy to add to any illustration with gel pens. White opaque gel pens are perfect for adding highlights, as well as shiny surfaces and glittery speckles.

White Pencil. White pencil marks create a beautiful effect on darker papers. Use them for bridal designs, veils, lace, or any other delicate designs.

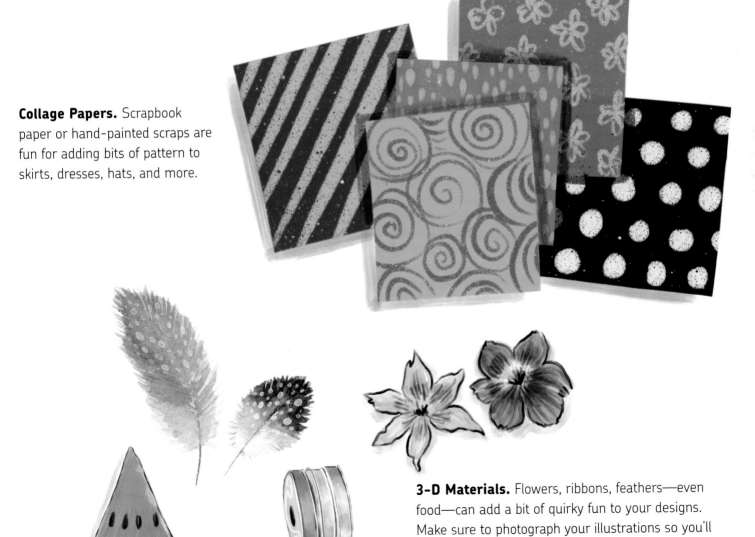

Collage Papers. Scrapbook paper or hand-painted scraps are fun for adding bits of pattern to skirts, dresses, hats, and more.

3-D Materials. Flowers, ribbons, feathers—even food—can add a bit of quirky fun to your designs. Make sure to photograph your illustrations so you'll have your ideas saved for future use!

Basic Figure Drawing

Before you can design the clothes, you've got to draw the models. This can be the biggest obstacle for many aspiring designers. Drawing people seems hard at first, but don't worry! There are a few different ways to draw figures.

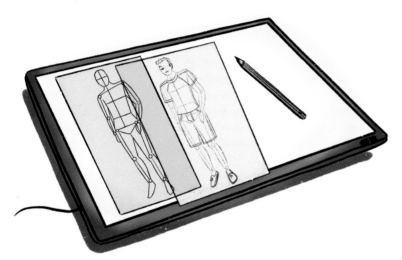

Light Box & Templates

Using templates is a great way to get started drawing! Scan or photocopy one or more of the templates shown on pages 124-127. Place the template on the light box with your choice of paper over the top. Turn on the light box to illuminate the template beneath the clean sheet of paper. Trace the figure lightly onto your paper to transfer the template to the page.

You can create endless designs using one template! You can also adapt an existing template (Figure 1) to any body type. Create a larger figure by tracing along the template just outside the lines shown (Figure 2). For narrower shoulders or a slender body type, trace along the template just inside the lines (Figure 3).

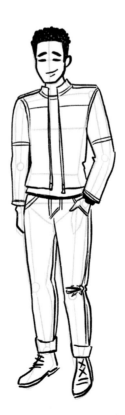

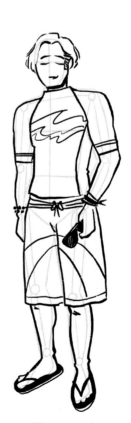

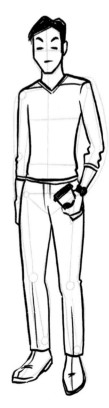

Figure 1

Figure 2

Figure 3

Gesture Drawing

If you love a sketchy quality, gesture drawings are for you. Gesture drawing focuses on shape and volume. This method involves working quickly in pencil, without erasing, while glancing back and forth from the subject (or reference photo) to the drawing page. The only goal is to achieve good balance and proportion. Drawings made this way usually reflect the artist's unique hand and style. There may be sharp lines and angles or sweeping curves and soft edges. Once you're satisfied with your sketch, you'll darken the final shapes to bring the drawing forward.

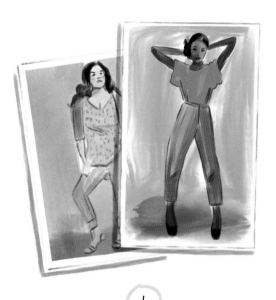 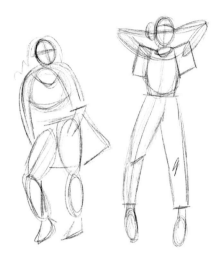 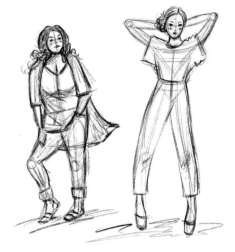

1

To practice gesture drawing, select a few reference photos.

2

Sketch quickly from your photos with a focus on shape, proportion, and balance.

3

Darken the best lines, and then add some detail and shading.

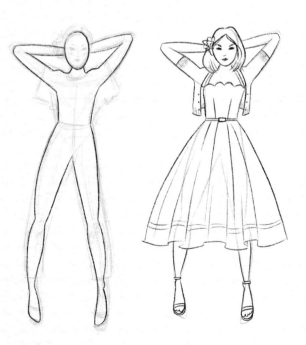

To create a template from a gesture drawing, place the drawing on a light box and trace main figure lines onto a clean sheet of paper. Then sketch a new fashion onto your blank template!

Architectural Figure Building

Architectural figure building is a useful technique for achieving accurate proportions. (It is also the technique used in the step-by-step projects featured throughout the book.) Architectural figure building requires you to start a figure using simple lines and angles as key points of reference, as shown in the steps on the opposite page.

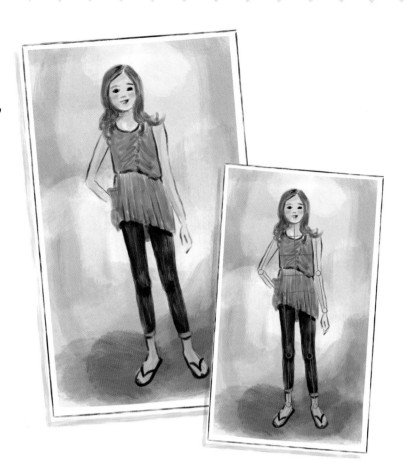

Figure-Building Tips

Each figure design starts with a basic stick-like shape, but there are other considerations to take into account.

- Does a hand rest on a hip? Is an arm raised? If so, where does the elbow align with the head? In this methodical approach, visualizing and drawing these details realistically helps establish accurate proportions in the final illustration.

- Focus on the horizontal lines that denote the shoulders, chest, waist, and hips. Notice if the midline (think of it like the spine) is vertical or slanted. Also recognize if the hipline is tilted. Often, models will stand with one hip popped out, which creates an angled tilt. A model walking the runway will also have a slanted hipline.

- Indicate the joints with small dots or circles. This is a great tool for checking proportions. Elbows usually hit at the waist. Wrists are usually one-third of the way between the hips and knees.

Once you train your eye to see the underlying architecture of a figure, you'll be able to create a template for any body type and shape.

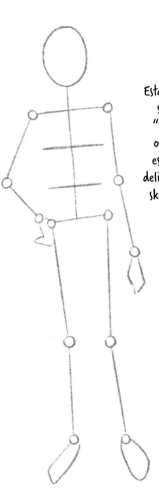

1

Establish the internal framework of the figure. First sketch an oval for the head, and then add the "line of action," or midline, to create the center of the torso. Next, add horizontal lines to begin establishing the figure. You should have lines that delineate the shoulder, chest, waist, and hips. As you sketch in these lines, you will establish the posture. Add lines for the arms and legs.

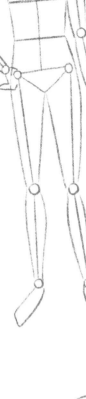

2

Once the basic stick figure is in place, begin filling in the form and volume of the model in any size or shape desired.

3

Begin creating the fashion you'd like to design. To make it more visually interesting, add a hairstyle and accessories, and suggest some facial features.

4

Clean up your lines with a kneaded eraser and refine the details.

Drawing on a Tablet

Drawing digitally on a tablet is convenient and portable, making it easy to design anywhere! Files are easy to clean up and make print-ready, plus there are tools you can use to experiment with color and pattern.

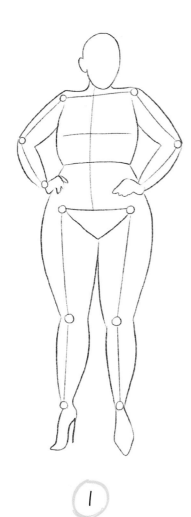

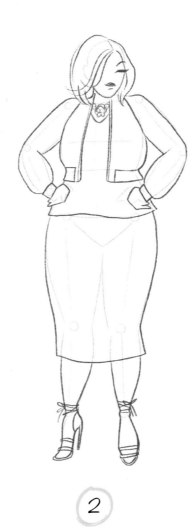

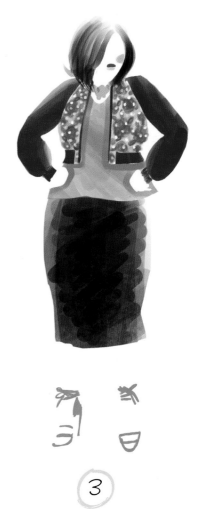

1

Sketch your figure on the tablet screen, or scan a template from the book and import it to your drawing program.

2

Reduce the opacity of the figure sketch layer. Make a new layer on top of the figure sketch. Draw your fashion design just like you would if you were using a light box. When you complete your design, turn off the figure sketch layer to reveal your clean drawing.

3

Keep your line art design layer on top and "Multiply" the layer. Next, add one or several layers underneath to color your clothing. You can use a variety of different brush textures to suit your taste. Choose from pencil, paint, ink, and more.

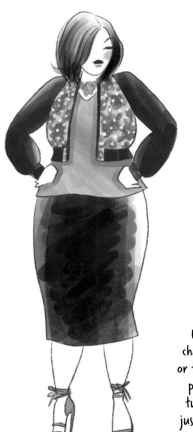

4

Use color-editing tools to change the entire color story or to experiment with just one part. This allows for fine-tuning to get color palettes just right, while your line art layer stays perfectly intact!

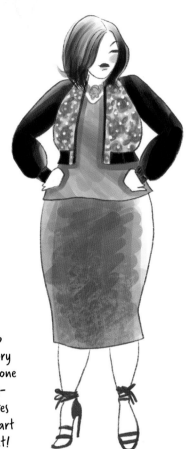

Digital "Ink."
Use a stylus to create a minimalist design using only gray or black. This effect has a modern feel to it.

Fashion for Everyone!

Fashion is for everyone—and it's definitely *not* a one-size-fits-all game! Today's designers understand that fashion serves purposes outside of the utilitarian function of simply dressing people. Fashion supports creative expression, confidence, and individuality. Here are some tips to get you started designing fashions for a wide range of people of all shapes and sizes!

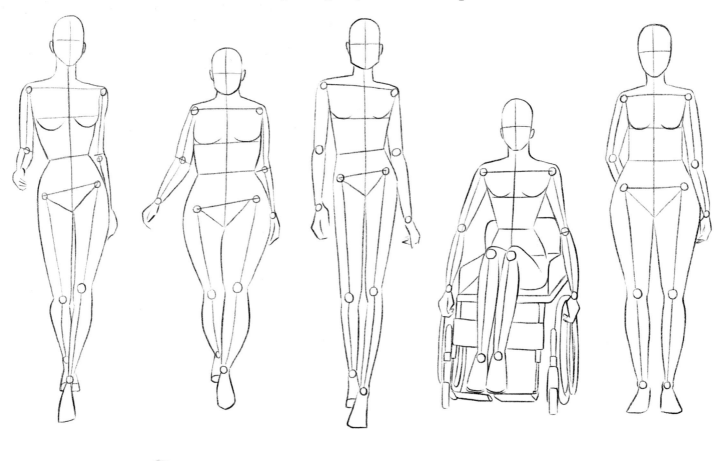

1

Design for everybody and every *body*!
Practice drawing all sorts of figure proportions like the ones shown above. Find inspiration from fashion and lifestyle magazines, social media, and on television. Red Carpet wrap-ups are especially great since they show full-length poses of celebrities of all shapes and sizes.

2

Select a favorite outfit from your closet or a magazine. Adapt the design to fit a variety of body types. Don't forget to add accessories!

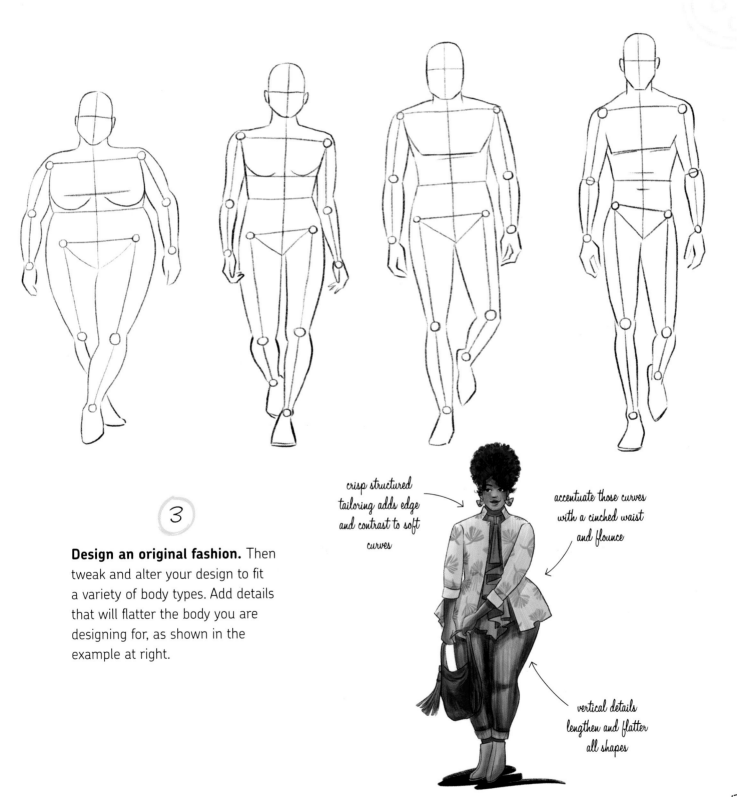

3

Design an original fashion. Then tweak and alter your design to fit a variety of body types. Add details that will flatter the body you are designing for, as shown in the example at right.

crisp structured tailoring adds edge and contrast to soft curves

accentuate those curves with a cinched waist and flounce

vertical details lengthen and flatter all shapes

Adaptive Apparel

Fashion can and should be customized to meet the needs of people with disabilities. A growing number of high-end fashion brands are rolling out lines that take these clients' needs into account by positioning seams, zippers, buttons, and the like in areas that are easy to manage. Other considerations include using breathable fabrics, incorporating Velcro, magnetic closures, and other easy-to-use fasteners into designs, and designing pockets, tags, and other details for comfort. Design fashions that complement all body types and also accommodate mobility devices.

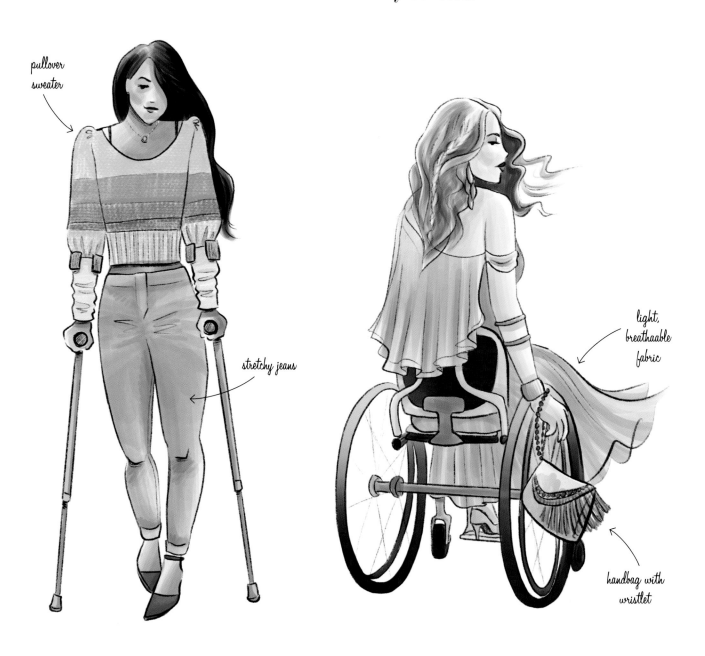

pullover sweater

stretchy jeans

light, breathaable fabric

handbag with wristlet

Making Faces

When drawing figures in fashion design, the focus is generally on the garment, so drawing simple faces and hairstyles is common. For example, drawing one eye and a mouth can be enough to indicate expression without worrying about getting the proportions right. That's not to say that you can't be more detailed if you like. Trust your instincts and draw your models in a way that feels right for your designs. Likewise, hairstyles can be minimal or bold. Think about the personality of your design and match your hairstyle and facial expressions to that tone.

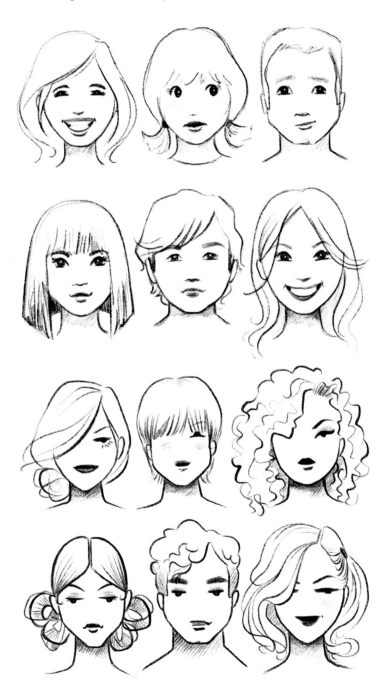

Keeping a Sketchbook

Inspiration can strike at any time, and a trusty sketchbook is the best place to capture your brilliant ideas as they happen! Jot down an idea for a reversible jacket or sketch a diagram for a shoe. Maybe the colors in a piece of street art will inspire a quirky graphic tee or a ball gown. Or perhaps you'll want to create a textures library. Carrying a sketchbook means you'll be able to capture inspiration when it strikes!

Sketchy Spontaneity. Who wouldn't love a peek inside the sketchbook of a fashion design icon? These scribbled ideas and messily sketched musings are the stuff of dreams! Fill a notebook with partial ideas, flashes of brilliance, and pencil sketches galore! Working quickly when inspiration strikes is where the magic happens, and your notebooks act as idea factories on days when the creativity is not flowing so freely. Add color with paint if the mood strikes!

Flatlay Fashions

Occasionally, you might find that you want to skip drawing figures and jump straight into the design part. Creating hand-drawn flatlay fashions—curating all of the wardrobe essentials into one complete look—is a fun way to get the creative juices flowing. The term "flatlay" refers to styling a complete outfit—kind of like you might do when you lay clothing and accessories across the bed to pull together a look.

To draw a flatlay design, sketch one central item of clothing—such as a patterned sundress—then build an outfit around it. You might add sandals or flip-flops, sunglasses, a straw hat, and a summery tote for a perfect day at the beach. Your sketchbook is perfect for creating flatlay designs.

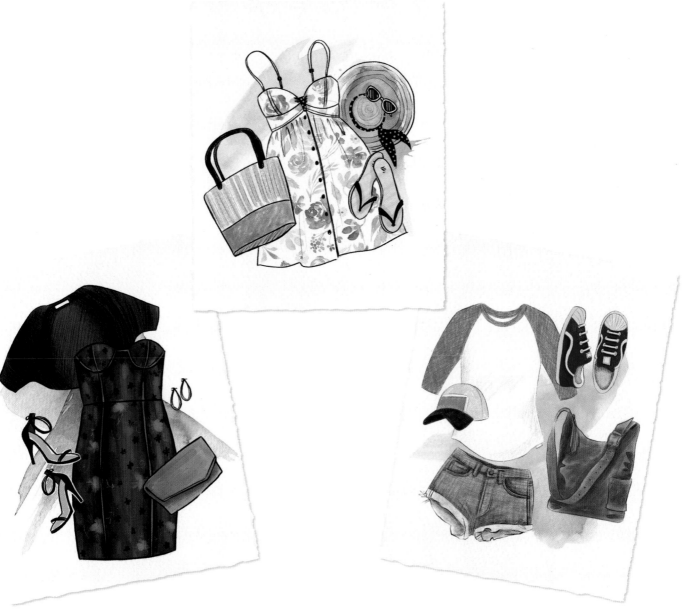

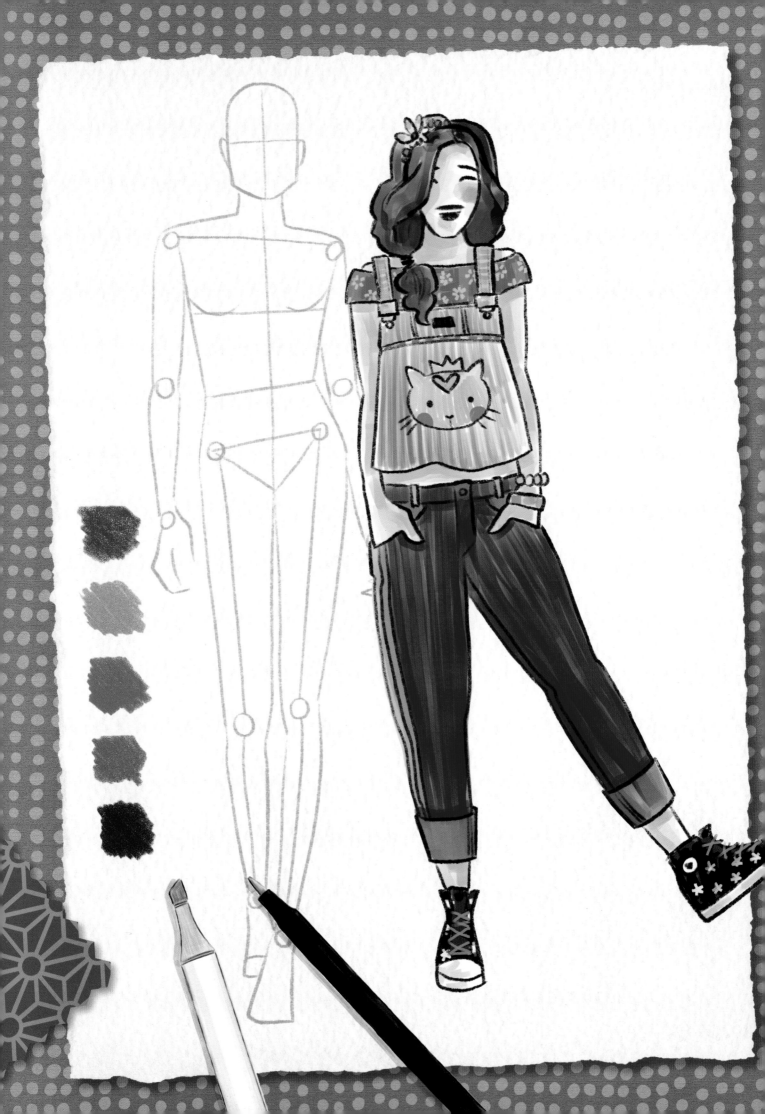

Chapter 2

Express Yourself

Uncovering Your Style

The quiz below is designed to help reveal what makes you tick when it comes to fashion. Use your discoveries as a roadmap that leads you directly into the land of your personal style. Follow it to create something fabulous—or abandon it and create something totally outside of your comfort zone!

Part I: Q & A

Review the questions below and write your answers on a separate sheet of paper or in a notebook; then consider how your responses help inform your aesthetic as a designer. Remember, there are no "right" or "wrong" answers!

1. What color(s) appear most in your closet?

2. What color(s) do you dislike?

3. What pattern(s) appear most in your closet (for example, stripes, polka dots, paisley, etc.)?

4. What pattern(s) do you dislike?

5. Which celebrity/designer styles do you like best?

6. What types of fashion do you draw most often? (for example, casual, formal, bridal gowns, accessories, etc.)?

7. If you can/could make your own clothes, what items do/would you most love to make?

8. Where do you picture your fashions being worn: in a big city, in a small town, on the runway?

9. Do you prefer dresses and skirts or jeans and khakis?

10. Do you prefer soft and flowy or structured and tailored clothes?

11. Do you like to express yourself through fashion?

12. When it comes to clothing, what are the most important things you look for:
a) comfort b) style c) a good fit d) usefulness

13. Do you like to: a) be ahead of trends
b) stay in tune with trends c) do your own thing

14. What style or types of clothing do you love the most?

15. Do you like to match, or do you prefer to mix colors and patterns?

16. When you spot someone wearing a unique outfit, what is your first thought:
a) "That's cool!" b) "That's weird!"

17. If you could only wear one shirt for the rest of your life, what type of shirt would you choose?

18. Do you like graphic or statement T-shirts?

19. What word best describes how you view yourself?
a) tough b) sweet c) rebellious d) cute
e) sophisticated

20. Would you like to design clothes that suit your personal fashion style or a completely different style?

21. What item of clothing should be in every closet?

22. What accessory should be in every closet?

23. What designer would you most like to work with or learn from?

24. What would you like the world to say about your designs?

Part II: Discovering Your Style Muses

Review the style muses shown on pages 26-29. In light of your answers from the quiz, have any of your opinions changed? Take some more time to answer the questions below.

Soft & Romantic (page 26)
What do you like or dislike about this sketchy, softly shaded style?

Chic & Minimal (page 26)
What do you like or dislike about this clean, bold, graphic style?

Playful & Cute (page 27)
What do you like or dislike about this whimsical style?

Avant Garde / Couture (page 28)
What do you like or dislike about this spontaneous, artsy style?

Editorial (page 29)
What do you like about this carefully rendered style?

Tip!

Finding Inspiration. A good designer can harvest ideas to fuel their creativity from almost anywhere. Inspiration can come from architecture, nature, animals, art, history— you name it! But inspiration also can be found in unexpected places, including billboards, posters, food packaging, toys, games, and music. Stay open to the things around you that stimulate your creativity, and use those ideas to fuel your passion for fashion!

Style Muses

The next few pages feature a range of styles and techniques—we'll call them style muses—to help jump-start your creativity. Notice how a particular drawing style lends itself to a specific type of fashion. For example, a quirky and playful outfit might be drawn in loose sweeping strokes, whereas chic and sophisticated apparel is usually drawn using clean, bold lines.

Soft & Romantic

If this style appeals to you, you might be a dreamer, a lover of romantic novels and history, or someone who adores soft colors, flowers, and pretty little details.

Your muse is soft-spoken, sweet, and gentle.

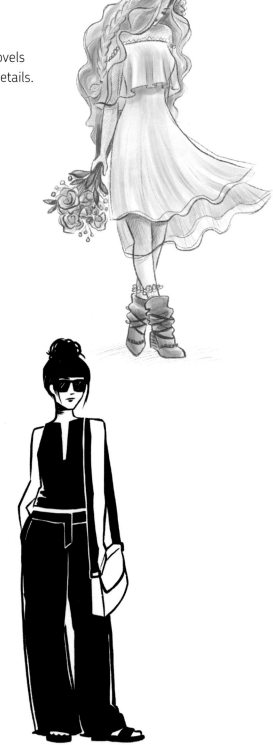

Drawing Style:
Sketchy, textural feel
Softly shaded
Thin, even lines
Muted tones, like Sepia

Fashion Style:
Flowing shapes
Sheer fabrics
Ruffles
Delicate details, like lace and embroidery
Florals

Chic & Minimal

If this style appeals to you, you may be a no-nonsense type who values results and efficiency. You care about looking pulled together, but you don't want to fuss with a million little details.

Your muse is a leader with a strong personality and confidence.

Drawing Style:
Black-and-white forms
Bold shapes
Graphic details
Dark marker or ink

Fashion Style:
Simple and confident
Clean and unfussy
Strong silhouettes
Comfort combined with sophistication
Minimal details
Tailored look

Playful & Cute

If this style appeals to you, you are probably a free spirit who loves having fun. You find joy in everything and you don't take yourself too seriously.

Your muse has a bright, chirpy personality and a perma-smile; they are everybody's best friend.

Drawing Style:
Illustrative
Vibrant colors and patterns
Chunky lines
Bright markers or colored pencils

Fashion Style:
Whimsical graphics
Unexpected clothing combinations
Fun and nostalgic
Playful characters
Kitschy accessories

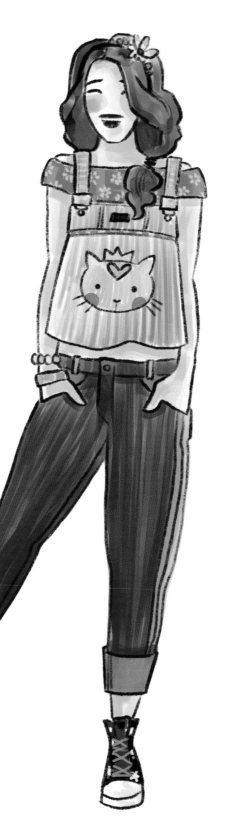

Avant Garde / Couture

If this style appeals to you, you are likely a pusher of boundaries and a lover of experimentation and high-art. You like to challenge the mainstream and make people do a double-take.

Your muse is a free-thinker and thought provocateur who doesn't mind being on display.

Drawing Style:

Spontaneous, loose lines
Unfinished curves
Abstract and slightly exaggerated
Bold colorful strokes

Fashion Style:

Fashion over function
Highly unique and creative
Artsy vibe
Unusual forms and silhouettes

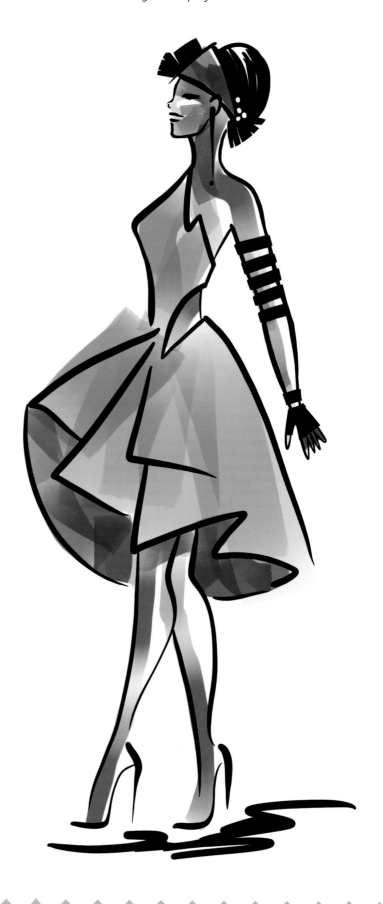

Editorial

If this style appeals to you, you have a vivid imagination and love to tell a story with clothing and accessories. You have a great eye and are always on the lookout for pieces that have a past or are truly special. You are inspired by characters in movies and in life. You might be an aspiring costume designer!

Your muse is Hollywood's "It" girl—past or present—who can morph and change into any character; she always gets a stylized spread in a high-fashion magazine.

Drawing Style:
Carefully rendered in draftsman pencil
Detailed and refined
Literal drawing style with shading and contour
Visible sketch lines

Fashion Style:
Creative and theatrical
Inspired by a story or character
Dramatic and intentional
Fashion-forward
Thoughtfully edited and detail focused

Tip!

Sketch every day, make mistakes,
create designs you hate,
and make designs you love!
Experiment with tools and styles,
and your personal aesthetic will
emerge and evolve—that's
a promise!

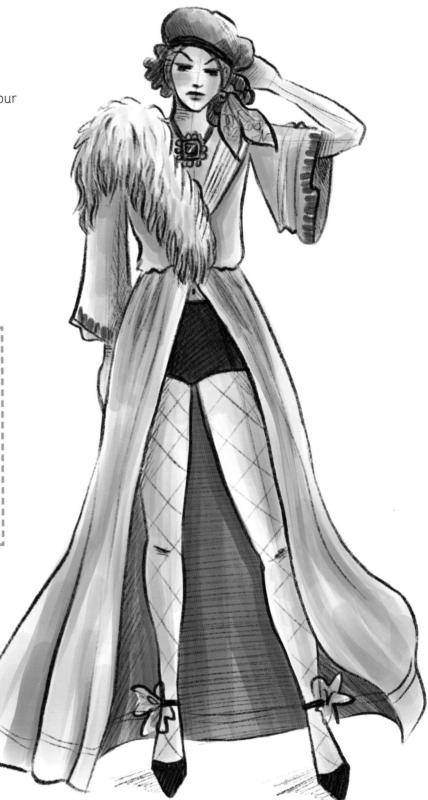

Capturing Your Vision

Now that you've learned some of the basics and have spent a bit of time practicing the mechanics of fashion illustration, you're ready to get creative using a variety of art tools to bring your vision to life! Let the fun begin!

Pencil & Pastel

When you're sketching on the go and paint is not an option, colored pencils and pastel pencils can give a rich, creamy jolt of color. These tools are perfect for creating the bold patterns and vibrant color combinations you might see in a Playful & Cute or Editorial design theme.

Helpful Tips

- Apply opaque colored pencil over darker colors for more control.

- Use loose scribbles to add a pop of color quickly.

- Add shading and/or shadows with gray, pale blue, or other neutral hues.

- Layer in thick or thin wobbly stripes for plaids or texture.

- Create pebbly tweed and wool textures with rough pencil strokes.

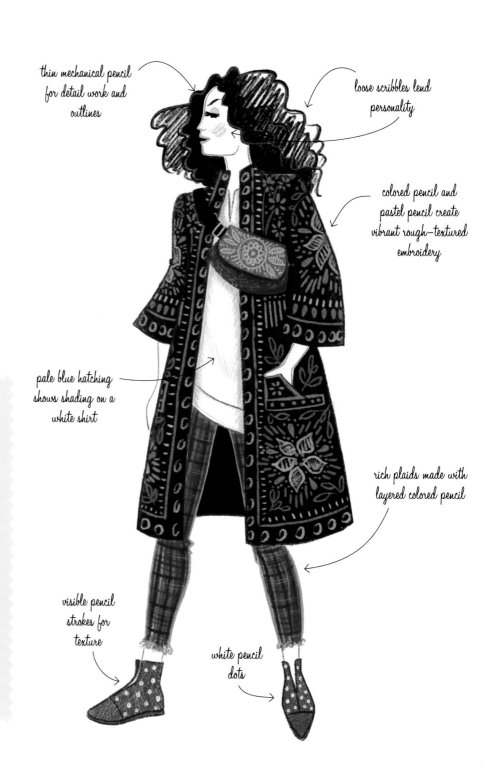

thin mechanical pencil for detail work and outlines

loose scribbles lend personality

colored pencil and pastel pencil create vibrant rough-textured embroidery

pale blue hatching shows shading on a white shirt

rich plaids made with layered colored pencil

visible pencil strokes for texture

white pencil dots

Marker

Many fashion illustrators rely on art markers and water-based markers for their work. Markers are a versatile tool and can be used effectively for almost any fashion design illustration. Because of the wide range of available colors, markers are especially fun to use on Playful & Cute and Avante Garde designs. The sophisticated palette of color options makes it easy to layer in stripes, dots, squiggles, and saturated hues.

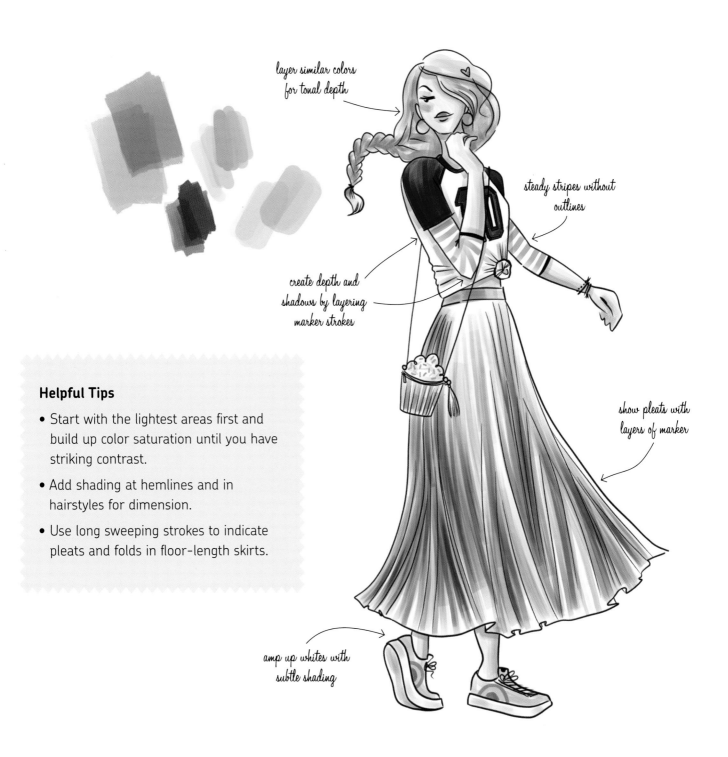

layer similar colors for tonal depth

steady stripes without outlines

create depth and shadows by layering marker strokes

show pleats with layers of marker

amp up whites with subtle shading

Helpful Tips

- Start with the lightest areas first and build up color saturation until you have striking contrast.
- Add shading at hemlines and in hairstyles for dimension.
- Use long sweeping strokes to indicate pleats and folds in floor-length skirts.

Dark Paper & Metallic Paint Pen or White Pencil

Nothing beats metallic paint pens and dark papers for adding shine to your designs.

Helpful Tips

- Use gold, silver, bronze, or other vibrantly colored metallic paint pens—they all work well on dark paper or card stock for creating jewelry, belt buckles, handbag hardware, sequins, studs, and other accessories.

- Use white pencil or pastel on mid-tone paper for bridal designs or to create dramatic highlights.

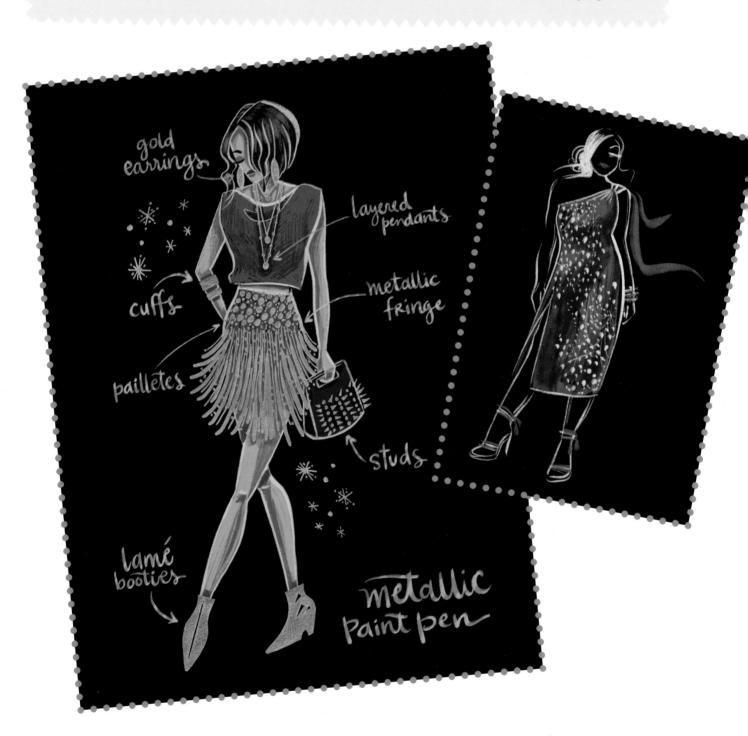

gold earrings

layered pendants

metallic fringe

cuffs

pailletes

studs

lamé booties

metallic paint pen

Ink

Ink pens deliver clean, professional results with contrast and intensity. Try out different types to see what works best for your style! Ink tools are ideal for creating designs that are Chic & Minimal.

Helpful Tips

- Use thin nibs on pigment ink pens for highly detailed work, tiny marks, and delicate hatched shading.

- Apply large areas of solid color quickly and easily with brush pens.

- Vary the pressure of your brush pen as you stroke to modify line weights and thickness.

- Scribble roughly with a brush pen to get interesting "scuffed" textures.

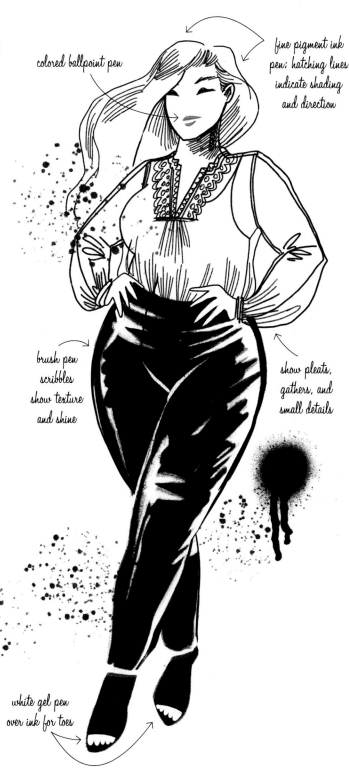

colored ballpoint pen

fine pigment ink pen; hatching lines indicate shading and direction

brush pen scribbles show texture and shine

show pleats, gathers, and small details

white gel pen over ink for toes

Inky Drama. A high-contrast ink illustration with exaggerated proportions feels edgy and cool. Create bold designs using nothing but black ink on white paper for instant drama with a dash of high fashion. This technique is perfect for metropolitan styles and no-nonsense fashions, especially when silhouettes or drape-like designs are the main focus.

Brush Pen & Variable Line Weight

Emphasizing line weights in fashion illustration makes drawings appear more interesting and professional. Line-weight drawings are perfect for Avant Garde/Couture design styles. Thinner line weights allow the eye to rest, while thicker line weights draw the eye to strong curves and angles, as well as to convey the weight of a figure or object. Balancing the variety of line thickness in the drawing will make even the simplest designs look more vibrant!

Helpful Tips

- Use a brush pen or waterbrush to practice creating lines and squiggles until you feel comfortable with this tool. Start by creating a page of lines and curves that start thin, using light pressure, and then gradually thicken with more pressure.

- Practice drawing lines that switch from thin to thick and back to thin again in one stroke.

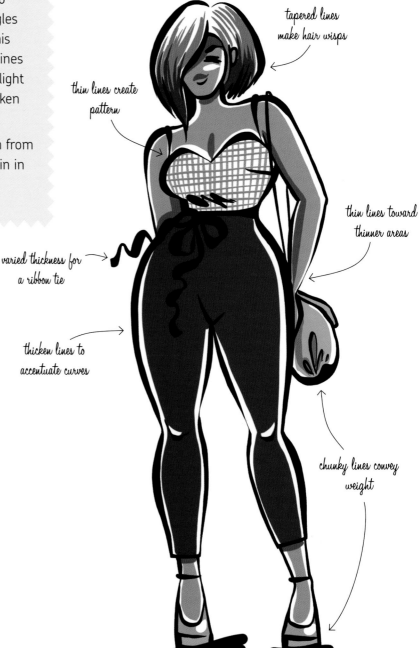

tapered lines make hair wisps

thin lines create pattern

thin lines toward thinner areas

varied thickness for a ribbon tie

thicken lines to accentuate curves

chunky lines convey weight

Mixed Media & Collage

If drawing prints and patterns isn't up your alley or you want to really mix things up, use collage papers to add a textural element to your fashion illustrations. Start by drawing your design and then using a light box to transfer it to your collage papers. You can also use a variety of mixed media to create truly unique fashions!

Helpful Tips

- Make your own collage papers by drawing or painting patterns onto scrapbook paper, or use washi tape, magazine pages—the sky is the limit!

- Snip bits of cloth into the shape of an overcoat.

- Cut a scrap of faux leather or pleather into a purse design.

- Crumple up some patterned paper and use it to represent a shopping bag.

- Apply shiny duct tape or washi tape to create striking boots or high heels.

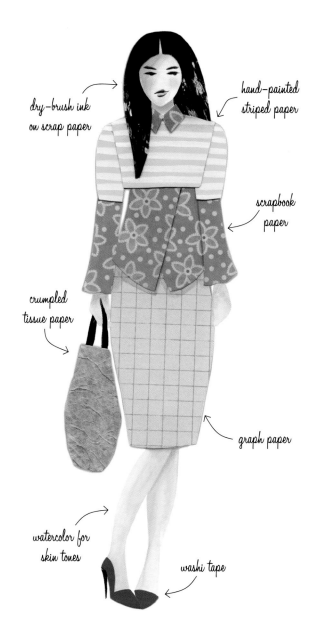

dry-brush ink on scrap paper

hand-painted striped paper

scrapbook paper

crumpled tissue paper

graph paper

watercolor for skin tones

washi tape

Add fun with found objects. Fabrics, flowers, sequins, glitter, painted papers, and even food add interest and creativity to your fashions! Think pressed flowers added to a wedding gown or thin ribbons glued onto a fringy skirt. Real sequins and glitter added to a cocktail dress design sketched on black paper adds maximum sparkle. And patterned fabrics can be used to show patchwork and prints.

Watercolor

Watercolor is undoubtedly one of the most versatile paint media available. It paints wet, but it dries fast. Watercolor layers easily. It is endlessly mixable and leaves beautiful "shimmering" effects, depending on how it is applied. It can add a quick pop of color to an ink drawing, or it can be used to create an entire illustration all on its own! Watercolor is ideal for designs that are Soft & Romantic.

Tube Watercolor. Tube paints are perfect for creating washes and for layering. They also tend to appear more transparent. Once the paint dries in a palette, it can be reactivated with a little water—so there is no waste! Use paintbrushes with tube paints.

Dry Pan Watercolor. Perfect for traveling or for painting on location. Activate dry paints with water using a waterbrush or paintbrush, and mix in the palette lid. Less water makes for a chalkier, more opaque application; more water increases the paint's transparency.

Techniques

Wet-onto-Dry. Apply watercolor to dry paper for precise results; the effect is similar to using a marker.

Wet-into-Wet. Applying watercolor to wet paper will allow the paint to flow into the wet space and create patterns and gradients, such as the colorful hair in the example shown on the opposite page.

Spatter. Load a brush with water and paint; then flick over the pages to add sparkle, splash, and pizzazz. The effect creates a dynamic feel that can liven up your illustrations.

Pouncing. Load a brush with paint, and then pounce it onto the page to create small puddles that dry in interesting ways. This is another unique way to create beautiful texture.

Layering. Overlapping wet paint onto dry paint can create tonal overlays that add depth and richness; this works especially well for gathered skirts and gowns.

Splash & Spatter. The combination of flowy watercolor with tightly drawn ink illustrations creates a perfect blend of hard and soft lines. Use line art to create your design; then add streaks, spatters, drips, and overlays of transparent watercolor.

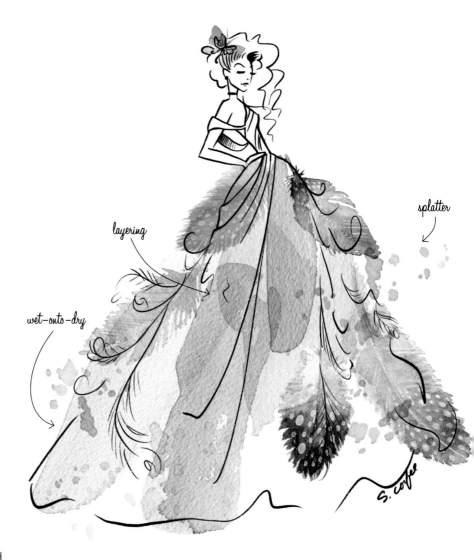

splatter

layering

wet-onto-dry

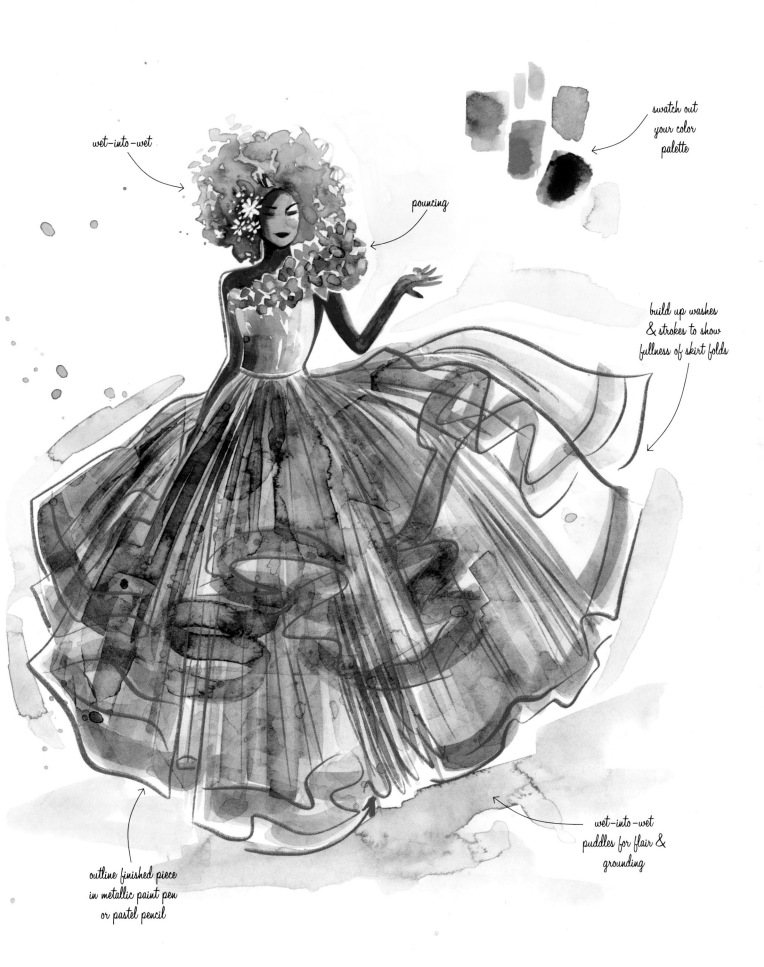

wet-into-wet

pouncing

swatch out
your color
palette

build up washes
& strokes to show
fullness of skirt folds

outline finished piece
in metallic paint pen
or pastel pencil

wet-into-wet
puddles for flair &
grounding

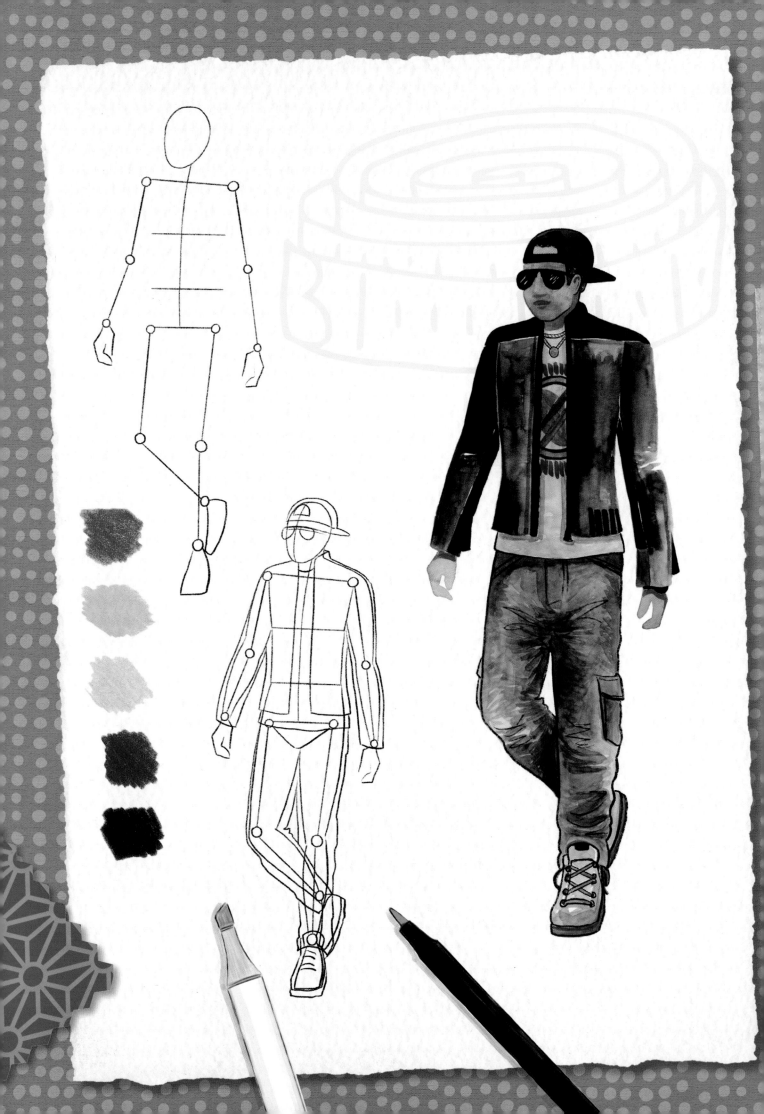

Iconic Designs: Step-by-Step Projects

Inspiration from Pop Culture

By now, you have probably learned more about your personal design style, discovered what types of fashion inspire you, and learned how to use a variety of tools to create special effects in your illustrations. You're well on your way to becoming a forward-thinking designer! For even more inspiration and ideas, it's helpful to look to iconic figures from pop culture—both past and present—to see how their styles might further influence your own work. After all, it's not uncommon for professional fashion designers to create complete outfits with certain celebrity muses in mind!

Trailblazing Artist

Inspired by Frida Kahlo

For this sketch, a simple, straightforward pose showing off the clothing and headdress works best.

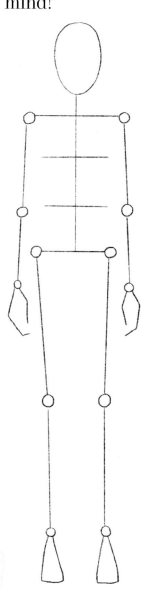

1

Draw an oval for the head and a stick figure made of lines and circles.

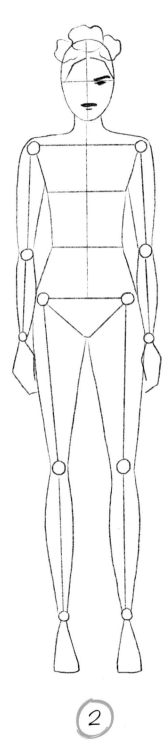

②

Add volume to the figure by outlining the
stick figure moving from joint to joint. Add
a midline and eyeline to the face, as well as
the flowers atop her head.

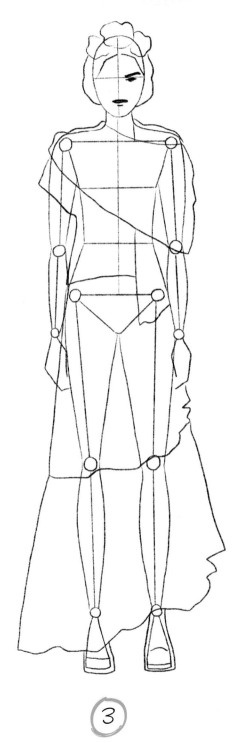

③

Sketch in the clothing, including a boxy
blouse, shoulder wrap, full skirt, and boots.

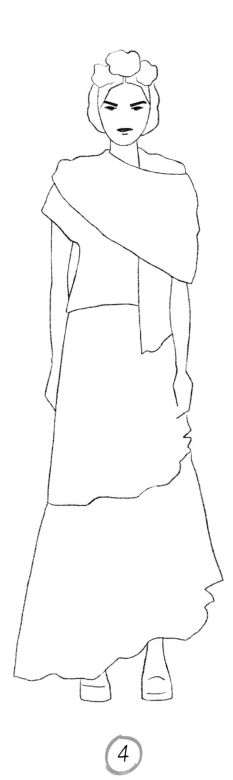

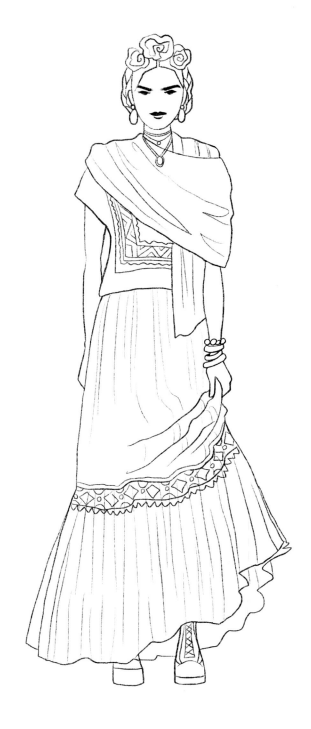

④

Erase unnecessary lines to reveal the
basic garments only.

⑤

Add the details! Since this fashion is
inspired by an iconic artist, try using
some motifs that are fitting to her style,
such as a square frame of ribbon trim on
the blouse and a band of decorative trim
on the skirt. Add bulky statement jewelry
to punch up the effect.

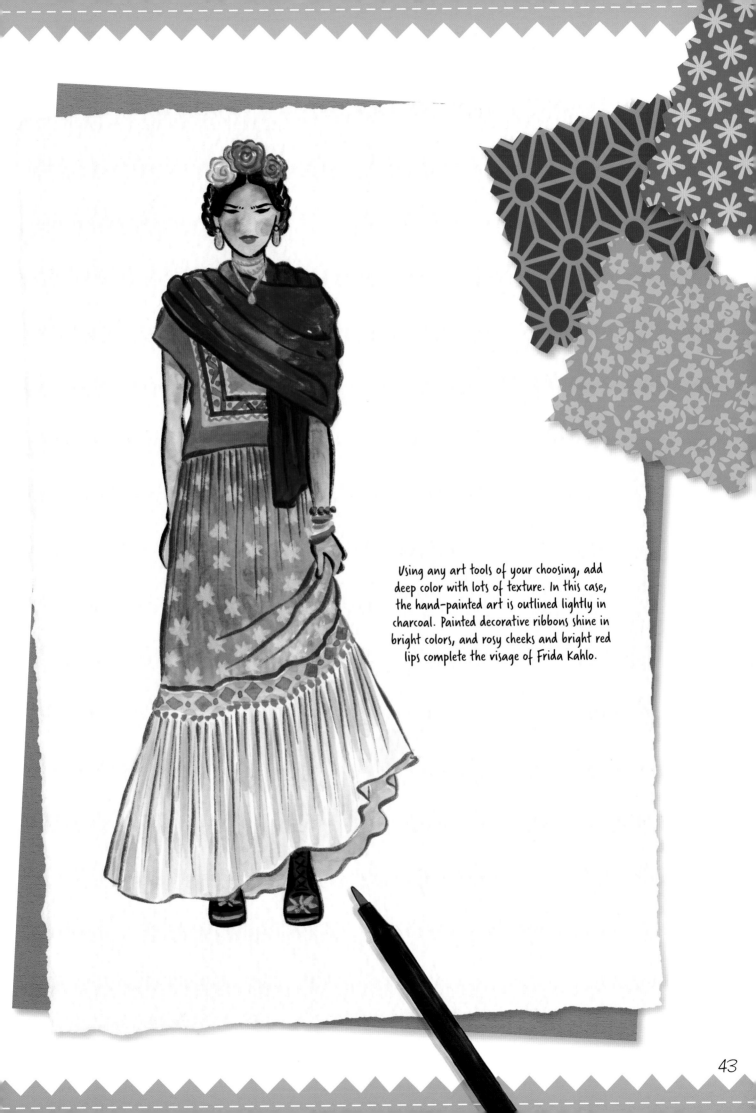

Using any art tools of your choosing, add deep color with lots of texture. In this case, the hand-painted art is outlined lightly in charcoal. Painted decorative ribbons shine in bright colors, and rosy cheeks and bright red lips complete the visage of Frida Kahlo.

Hollywood Classic

Inspired by Audrey Hepburn

Drawing a figure inspired by a celebrity or icon demands
a pose and look that suits their personality while also
highlighting the clothing.

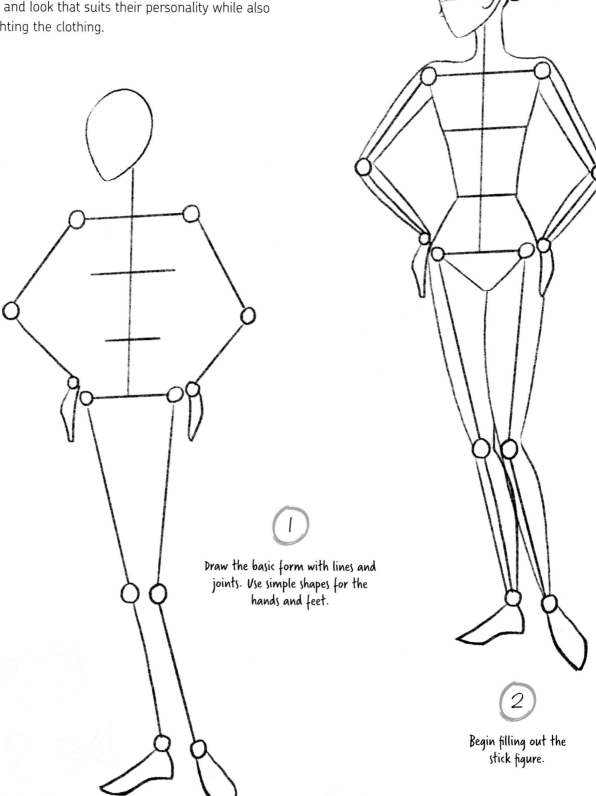

1

Draw the basic form with lines and
joints. Use simple shapes for the
hands and feet.

2

Begin filling out the
stick figure.

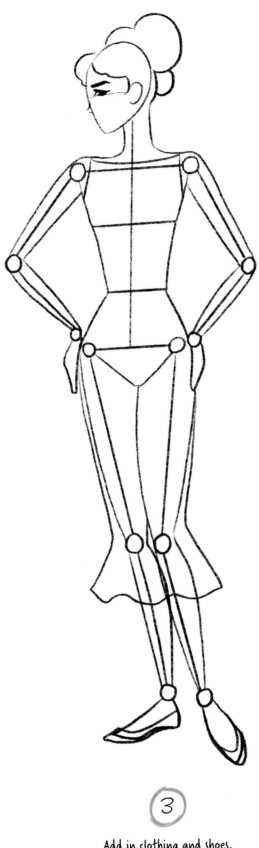

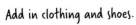

③

Add in clothing and shoes.

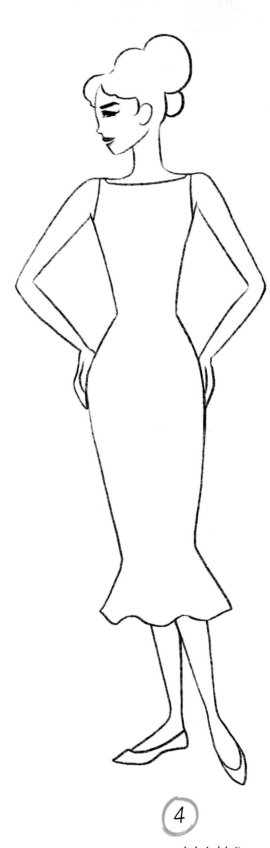

④

Erase any unneeded sketch lines.

(5)

Add the defining details that make the look unique. Tailored seamlines are shown here, plus wrist gloves and jewels!

Tip!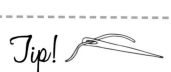

Black can appear dull and flat in an illustration. Use layered marker strokes starting with grays to give some shine and dimension. Then add white pencil tailoring lines to make the dress structure really pop.

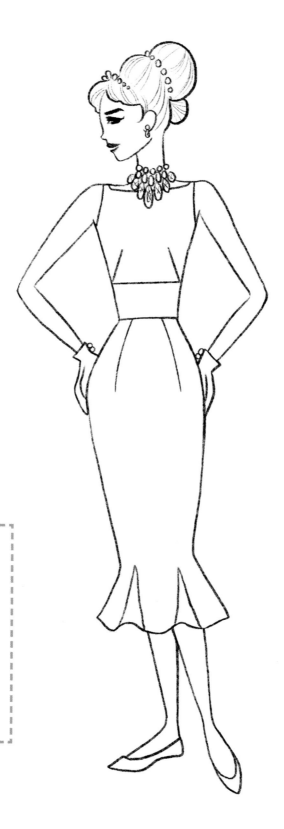

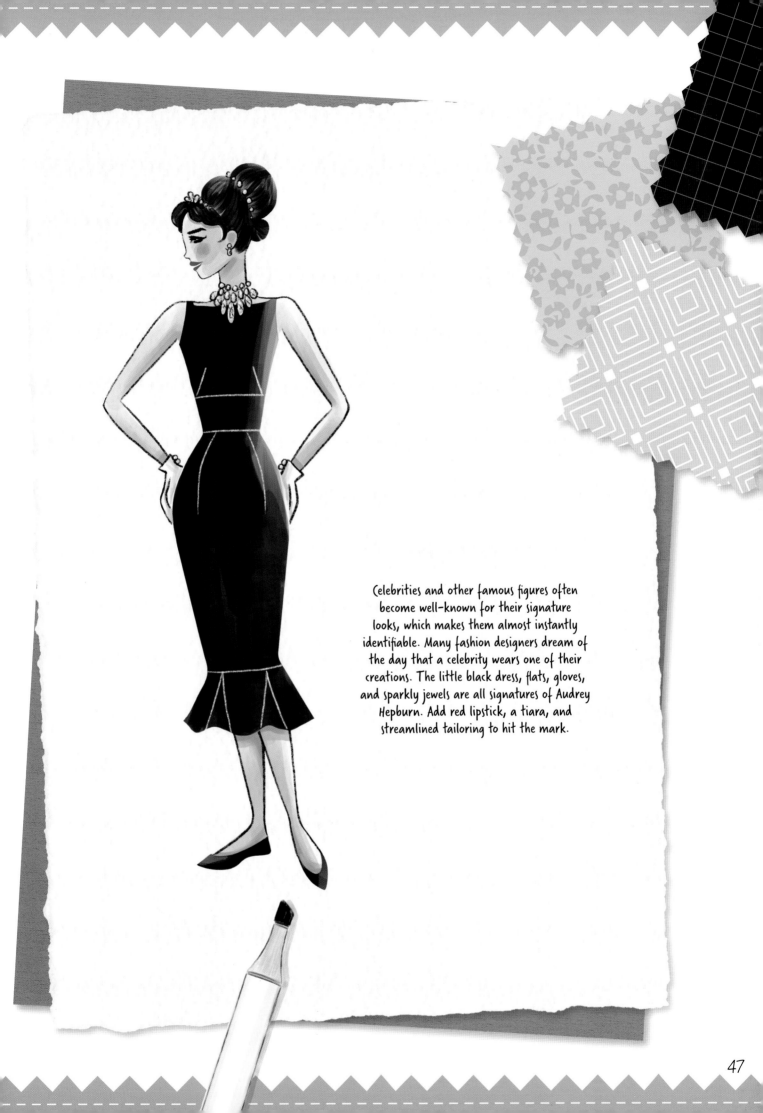

Celebrities and other famous figures often become well-known for their signature looks, which makes them almost instantly identifiable. Many fashion designers dream of the day that a celebrity wears one of their creations. The little black dress, flats, gloves, and sparkly jewels are all signatures of Audrey Hepburn. Add red lipstick, a tiara, and streamlined tailoring to hit the mark.

Music Mogul & Performer

Inspired by Jay-Z

A casual walking pose seems perfect for this fashion
icon with a cool urban style.

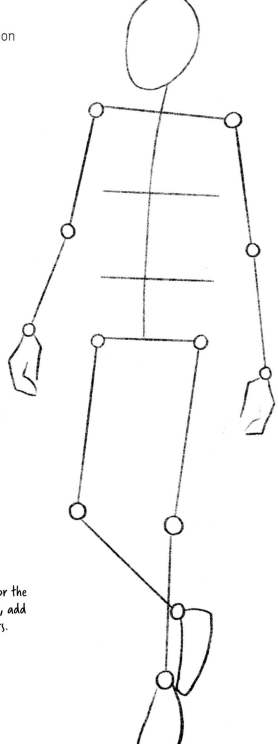

①

Sketch the pose with horizontal lines for the
shoulders, chest, waist, and hips. Next, add
lines and circles to denote the joints.

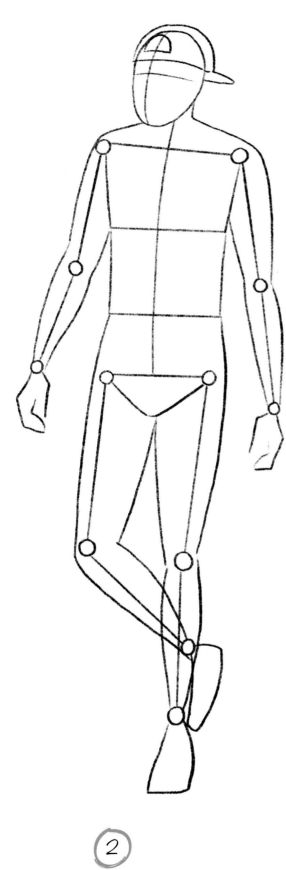

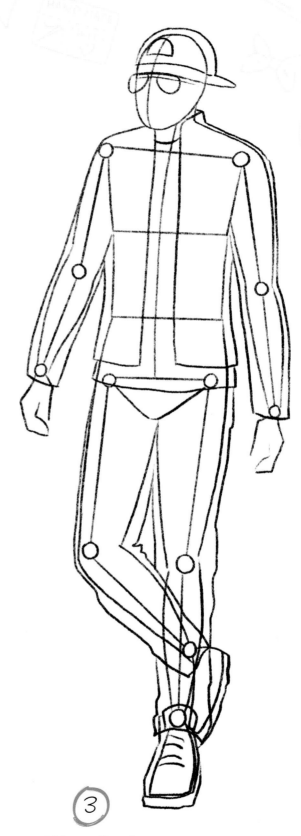

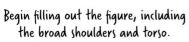

2

Begin filling out the figure, including
the broad shoulders and torso.

3

Add basic outlines for
the clothing.

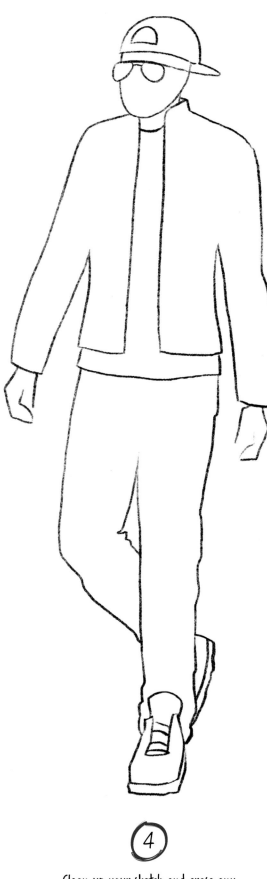

④

Clean up your sketch and erase any
unnecessary pencil marks.

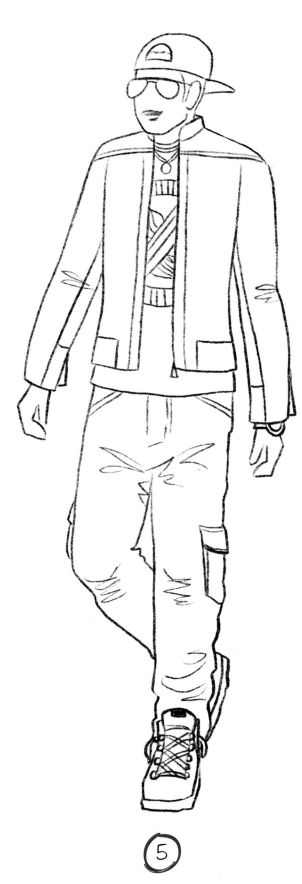

⑤

Style it up! A modern leather jacket, graphic T-shirt,
and baggy jeans are paired with shades, a cap, and
workman-style boots for a cool and casual look.

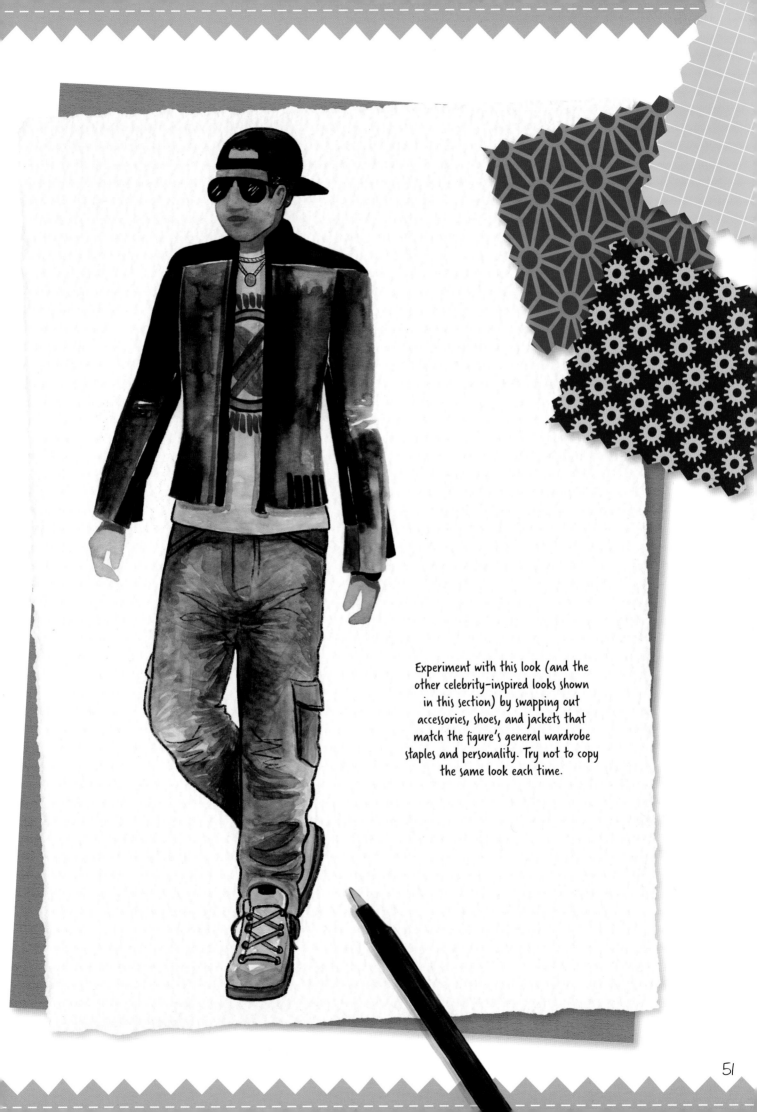

Experiment with this look (and the other celebrity-inspired looks shown in this section) by swapping out accessories, shoes, and jackets that match the figure's general wardrobe staples and personality. Try not to copy the same look each time.

Royally Chic

Inspired by Duchess of Sussex, Meghan Markle

A casual walking pose is common for a celebrity who is always under the watchful eye of everyone around the globe!

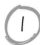

Start with the typical stick figure. Use an oval for the head and add horizontal lines for the shoulders, chest, waist, and hips. Add more lines and circles to show limb position.

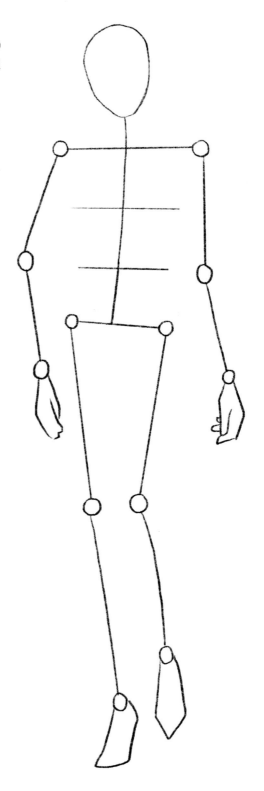

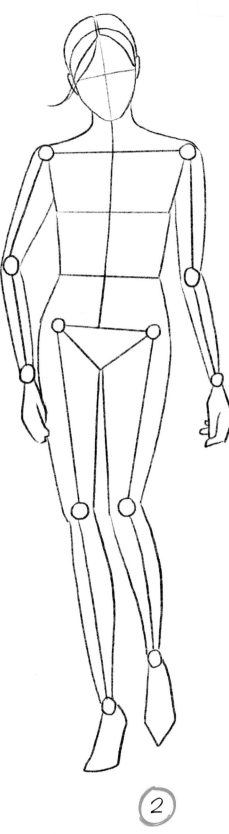

2

Add volume to the figure and sketch in
the beginning of the hairstyle.

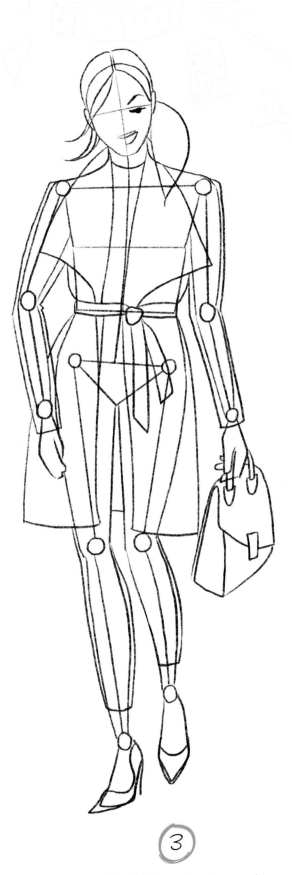

3

Draw the clothing as simply as possible.
Indicate the basics of the design,
including shape, length, and accessories.

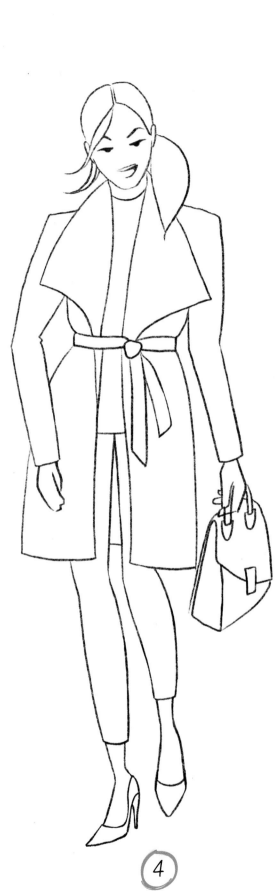

④

Erase sketch marks to give
yourself a clean drawing.

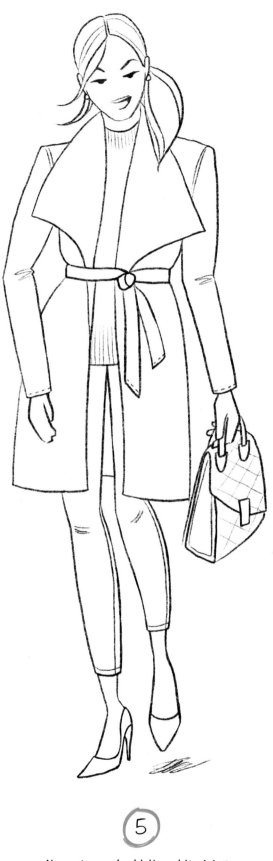

⑤

Now refine and add the subtle details.
This fashion icon won't need too much
because her style is all about simple forms
with little fuss.

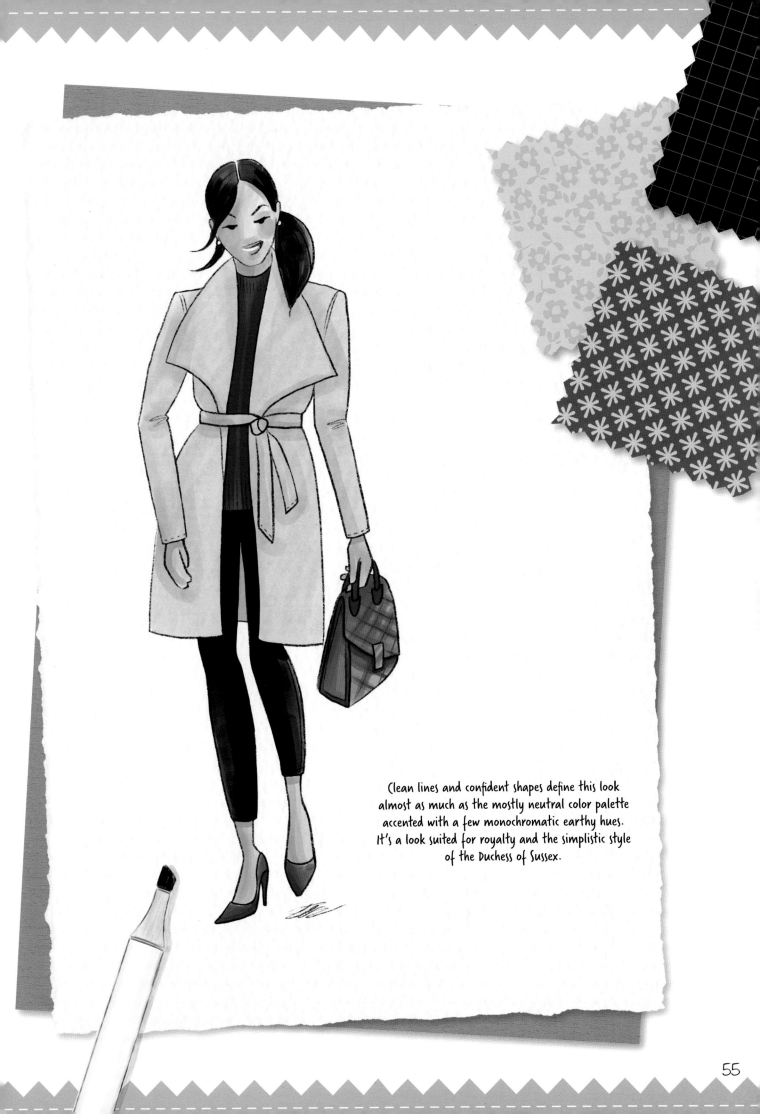

Clean lines and confident shapes define this look almost as much as the mostly neutral color palette accented with a few monochromatic earthy hues. It's a look suited for royalty and the simplistic style of the Duchess of Sussex.

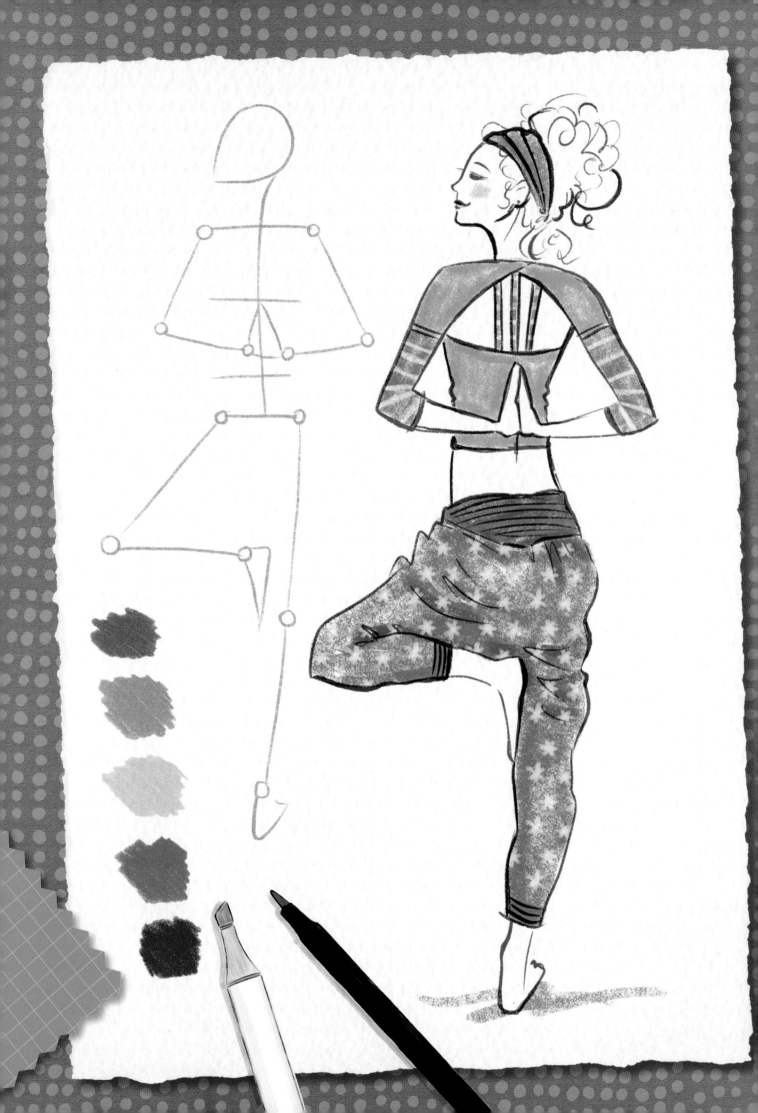

Everyday Fashions: Step-by-Step Projects

Contemporary Fashion Design

Fashion is literally all around us! From the aspiring musician rocking an edgy vibe to the cool poetry-reading hipster at the coffee shop, the influence of fashion cannot be denied. Whether at the beach, the yoga studio, a night out on the town, or the prom, there is a type of fashion to match every occasion and individual style. Here are a few project ideas to get you started imagining all of the ways you can design fashions for people from all backgrounds and body types.

Yoga Wear in Three Styles

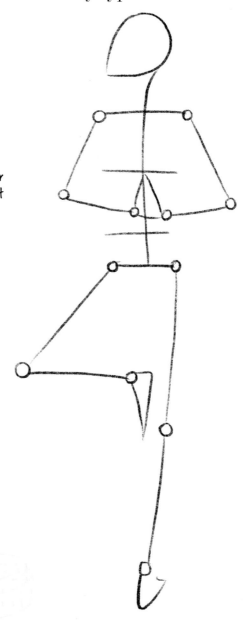

1

Sketch a stick figure, including circles for the joints. Use a yoga pose that will best show off the design you have planned.

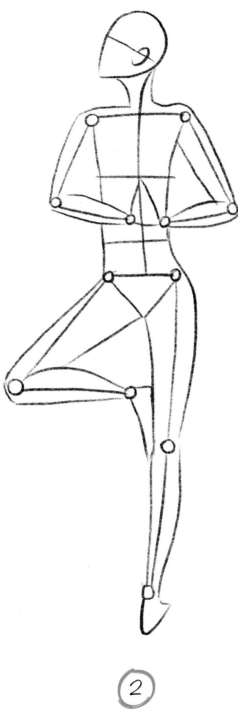

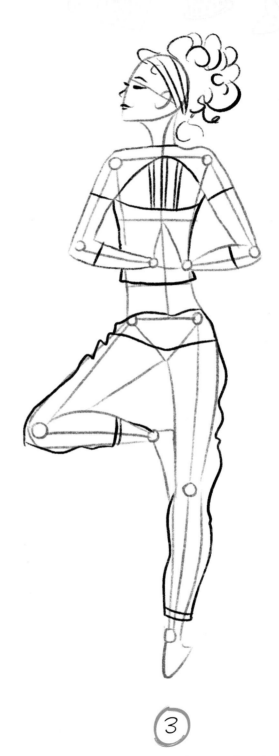

②

Add volume to the figure by "connecting the dots" from joint to joint. Add a line to the face that shows eye placement. Use simplified shapes to indicate hands and feet.

③

Add loose details of your design, such as sleeve length or silhouette. Add a few sketched lines to show hairstyle and a few swipes of the pencil to mark facial features. Work quickly and confidently for the best results.

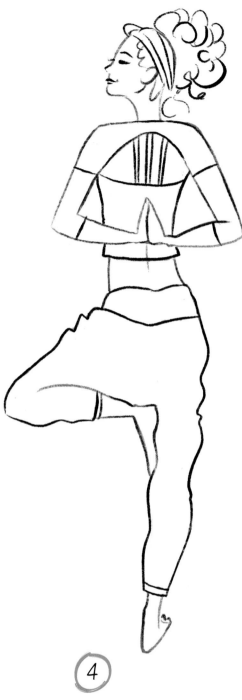

④

Clean up your illustration by
erasing unneeded lines. Darken the
strongest curves and details.

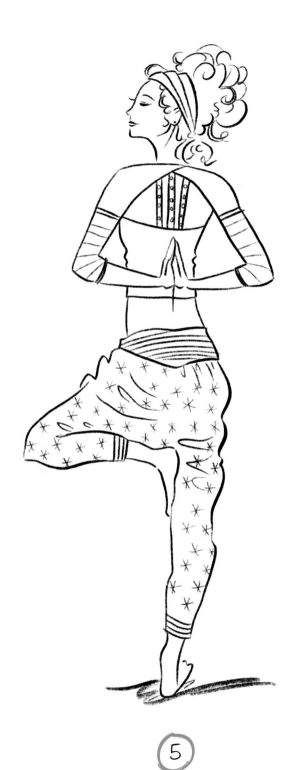

⑤

Add details to the clothing. Sketch
in seams, hems, patterns, folds, and
gathers. Finalize the garment's
construction and any other style points.

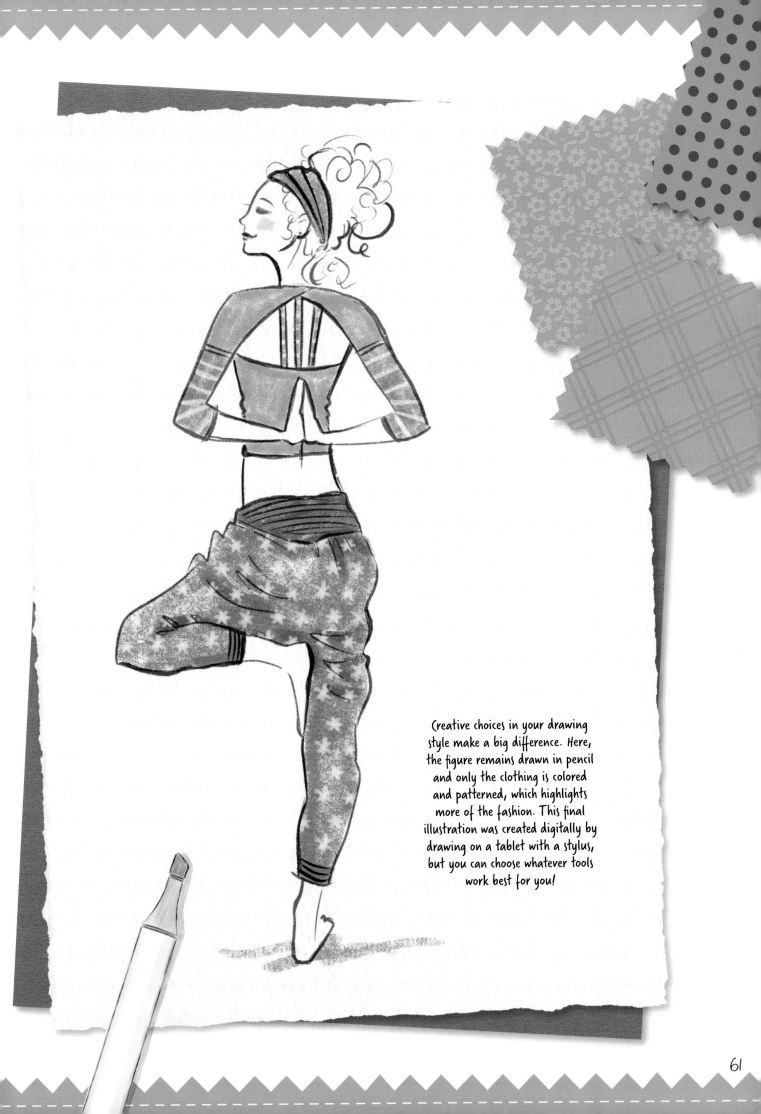

Creative choices in your drawing style make a big difference. Here, the figure remains drawn in pencil and only the clothing is colored and patterned, which highlights more of the fashion. This final illustration was created digitally by drawing on a tablet with a stylus, but you can choose whatever tools work best for you!

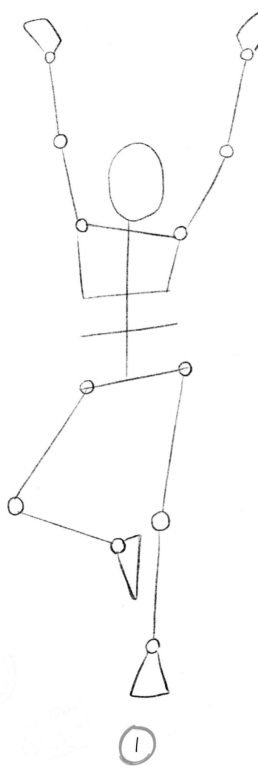

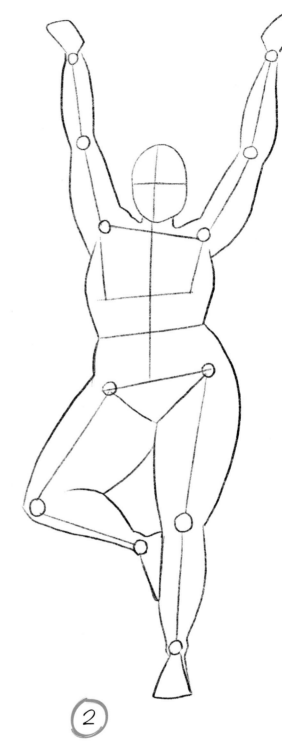

①

Draw a stick figure as a base for your model's pose. Start with an oval for the head and simple horizontal lines for the shoulders, chest, waist, and hips.

②

Add volume to your line art. For fuller figures, add more space around each joint and more curve to each line. Pay attention to whether the width of the waist is smaller or larger than the width of the hips on your model, and use those proportions to guide you.

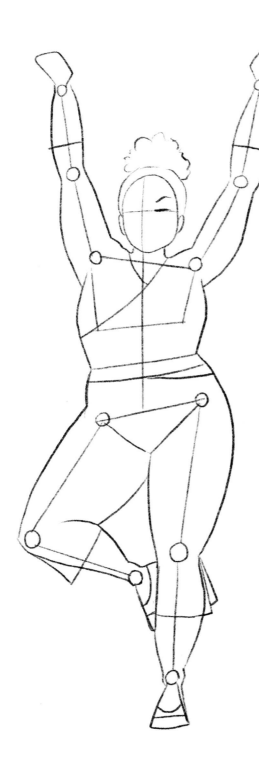

③

Create the clothing silhouette and basic shapes. Mark the neckline, sleeve length and any key design features, such as the split pant hems and wraparound sweater. Choose a hairstyle, and loosely sketch the shape.

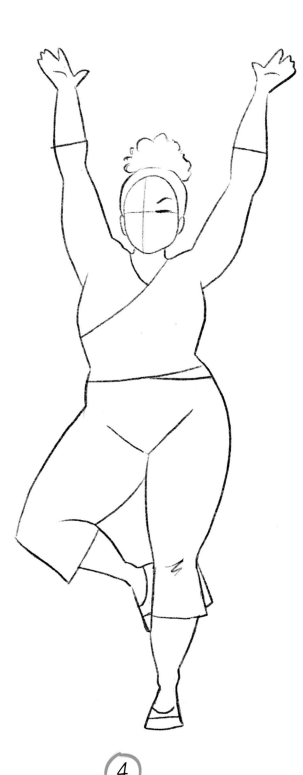

④

Erase your original lines and stray sketch marks. Seeing your clean silhouette will help you to choose final details and accessories.

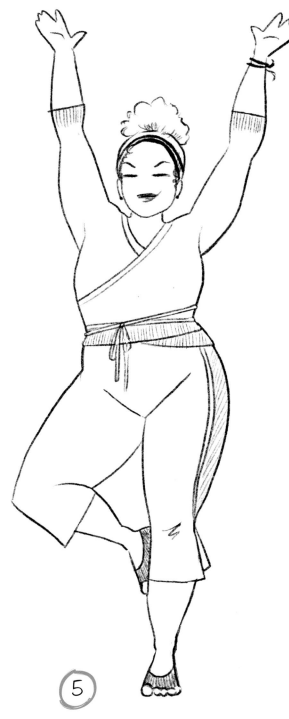

⑤

Refine the art adding the waist tie, sweater ribbing, leggings stripe, headbands, and yoga socks. Remember that style is in the details, so be thoughtful as you add both beautiful and practical touches.

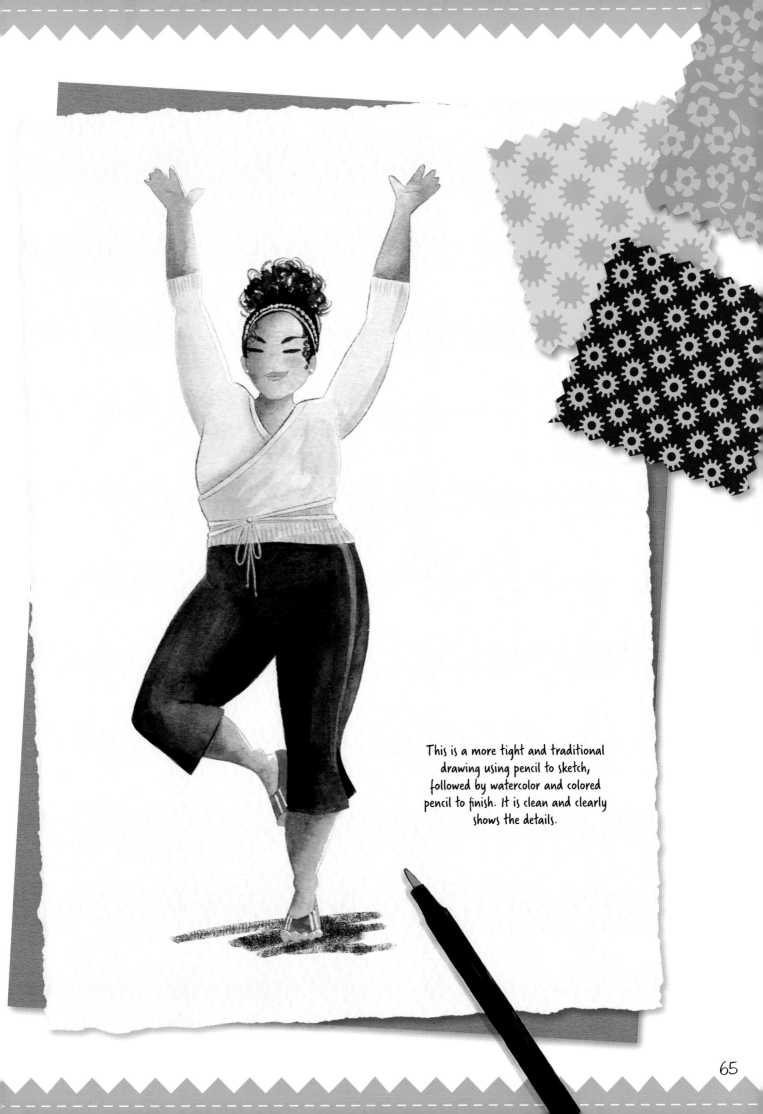

This is a more tight and traditional drawing using pencil to sketch, followed by watercolor and colored pencil to finish. It is clean and clearly shows the details.

1

Sketch a basic stick figure
in the desired pose.

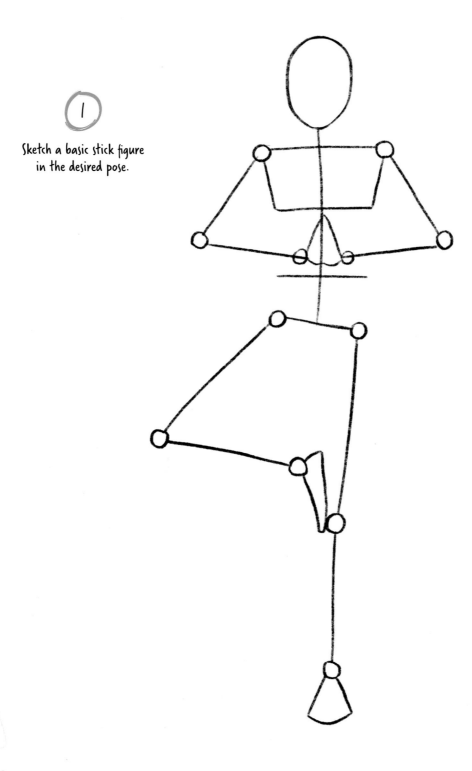

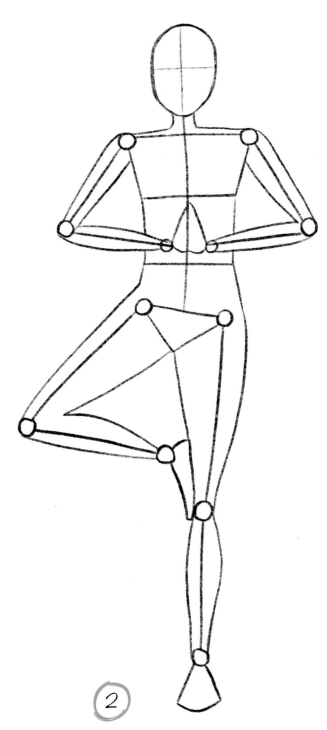

(2)

Continue to fill in the form as before.

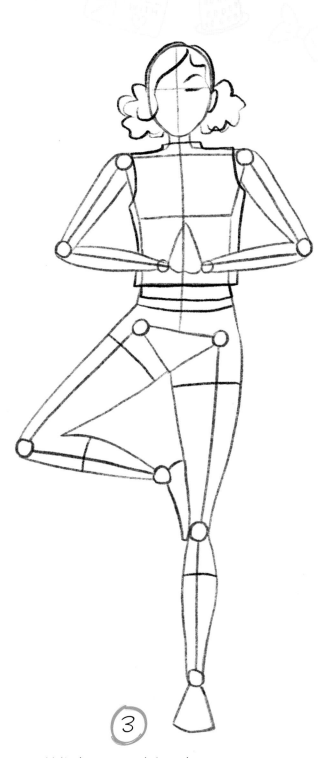

(3)

Add the basic garment shapes to your figure. Imagine the person wearing these clothes. What hairstyle would they have? Work out those details in this step.

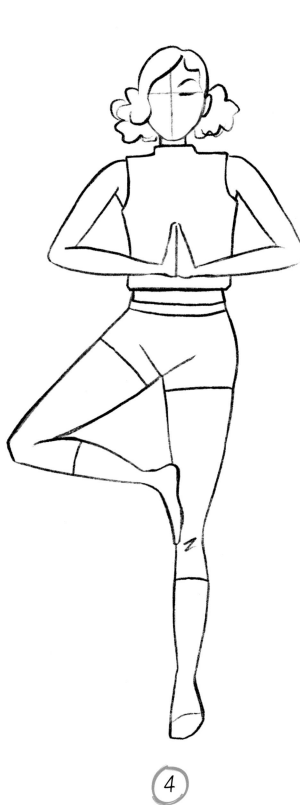

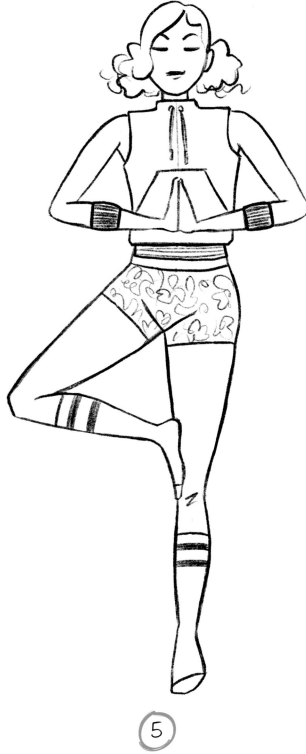

④

Clean up your sketch!

⑤

Add details that will set your garments apart. As a designer, your job is to impart your unique point of view on each item you create. Be sure that your designs reflect who you are—that is what will make them stand out.

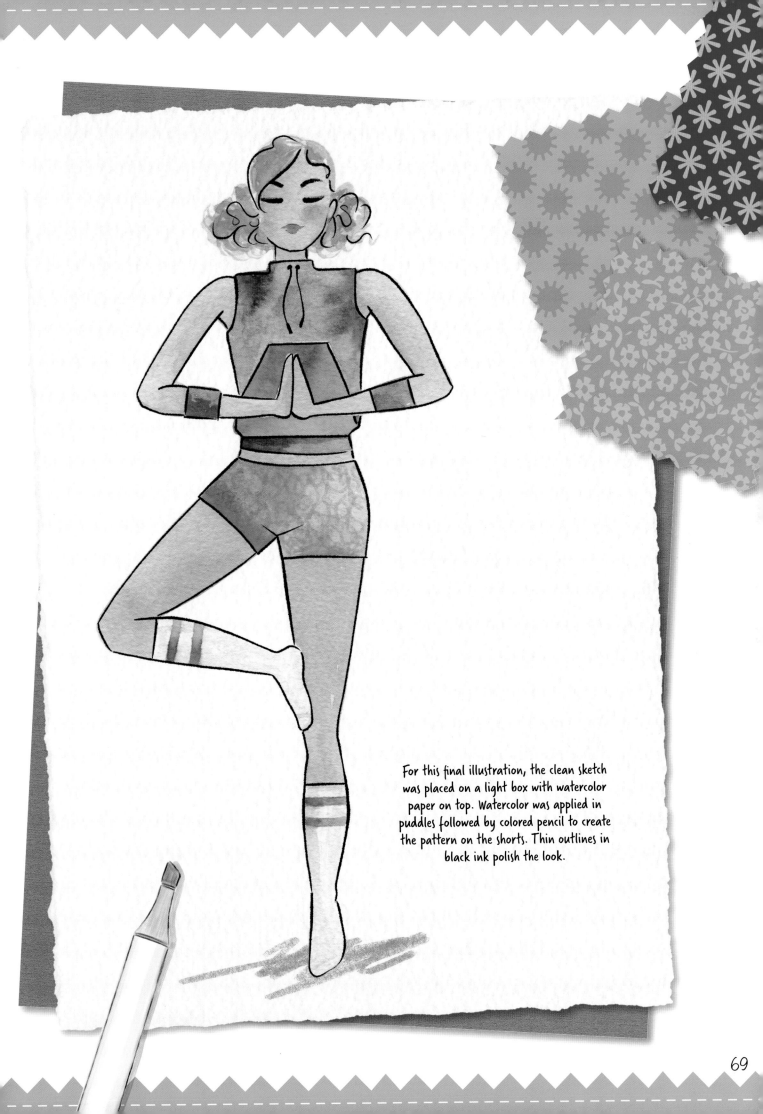

For this final illustration, the clean sketch was placed on a light box with watercolor paper on top. Watercolor was applied in puddles followed by colored pencil to create the pattern on the shorts. Thin outlines in black ink polish the look.

Casual Vibe

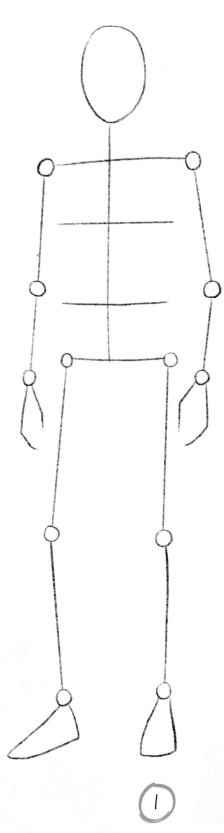

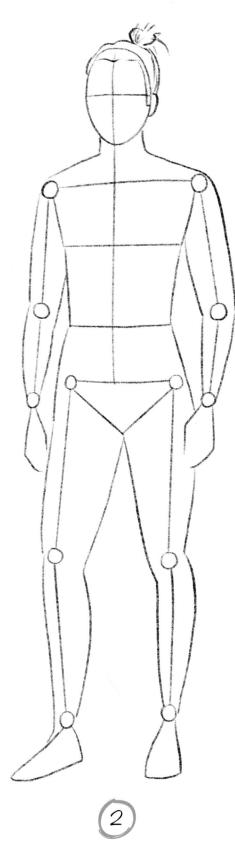

1

Start with a casual pose. Draw an oval for the head, shoulder lines, and stick limbs that show a loose posture.

2

Fill in the form with the body type to suit your design.

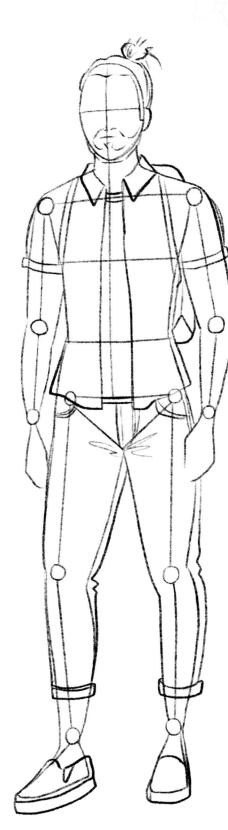

③

Begin the outlines of clothing. A casual
T-shirt layered with a short-sleeve button-
down, rolled skinny jeans, and slip-ons are
on fleek. A few faint pencil strokes suggest a
bit of facial hair.

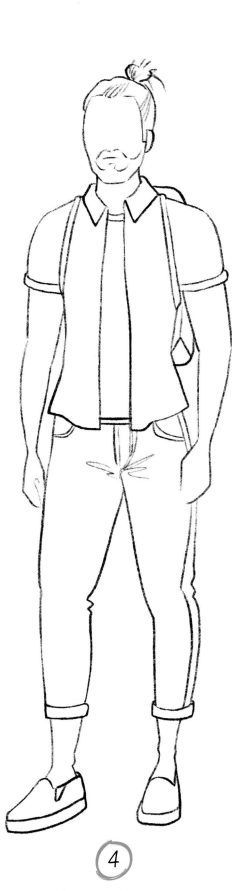

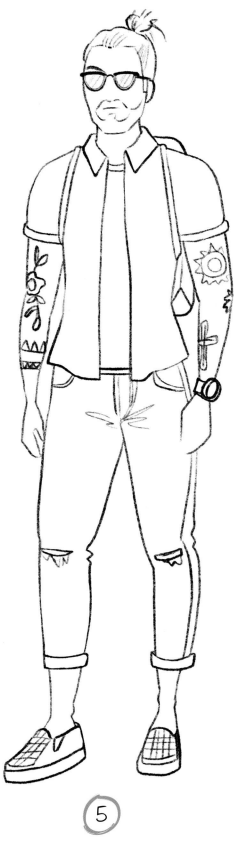

④

Erase unneeded pencil lines to clean up the sketch.

⑤

Have some fun adding details and accessories. This hipster sports a backpack, sunglasses, a chunky watch, checkerboard sneakers, and some body art. A few corded bracelets, and this guy puts the "hip" in hipster.

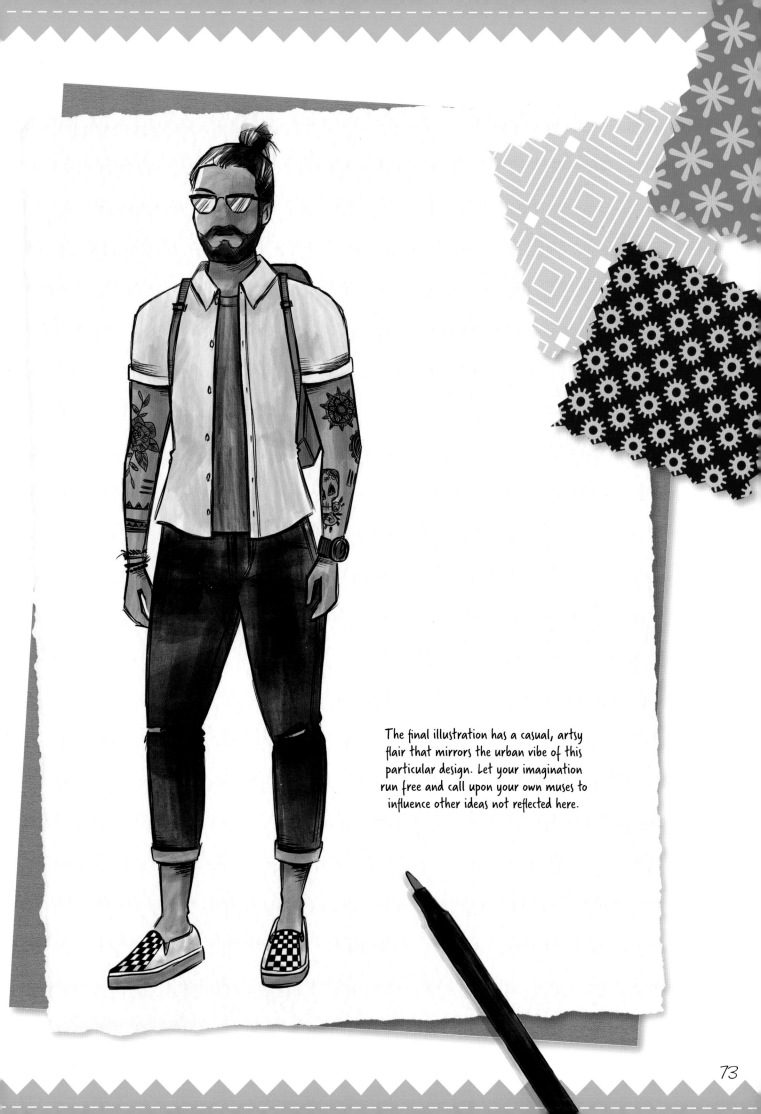

The final illustration has a casual, artsy flair that mirrors the urban vibe of this particular design. Let your imagination run free and call upon your own muses to influence other ideas not reflected here.

Surf & Sand

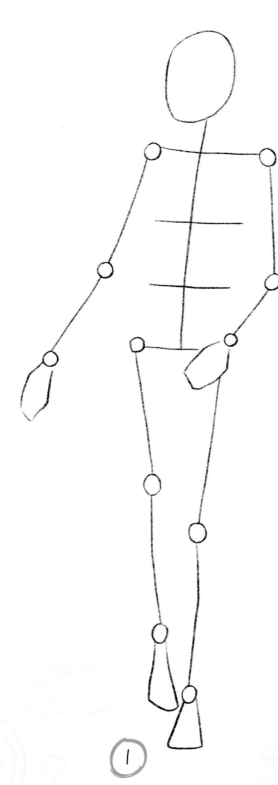

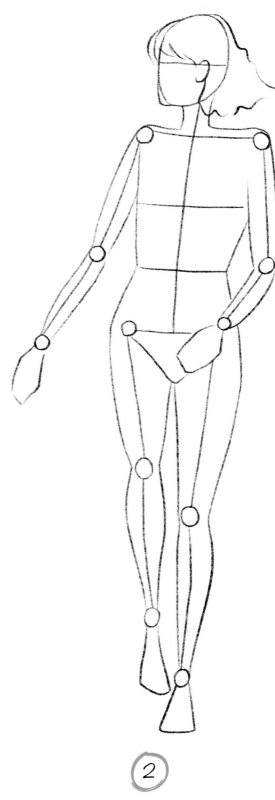

① This surfer begs to be in motion with hair blowing in the wind. Start with a stick figure in the desired pose.

② Add weight to the figure. This pose has the face in profile, so suggesting the chin is helpful for establishing proportion. Sketch quick messy waves of hair and a horizontal line to indicate eye placement.

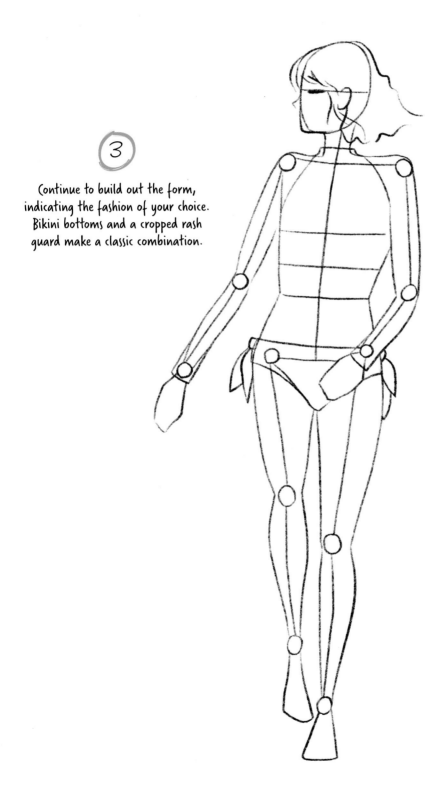

③

Continue to build out the form, indicating the fashion of your choice. Bikini bottoms and a cropped rash guard make a classic combination.

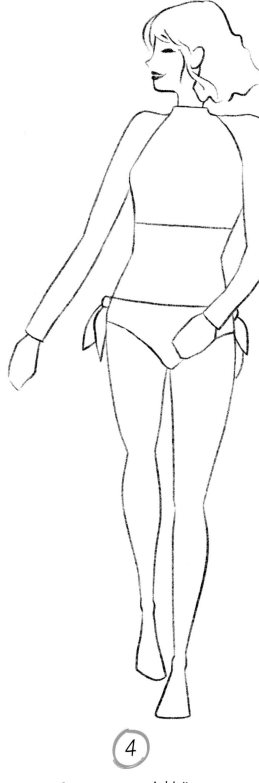

Tip!
The way you color and present your final illustrations not only speaks to your style and aesthetic, but also to the personality of your brand. Imagine this swimwear design in graphic black and white—it would change the feel entirely!

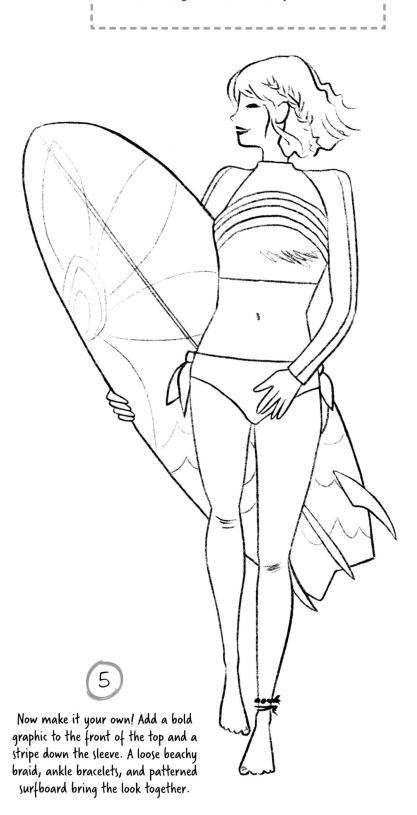

④

Erase unnecessary sketch lines and marks.

⑤

Now make it your own! Add a bold graphic to the front of the top and a stripe down the sleeve. A loose beachy braid, ankle bracelets, and patterned surfboard bring the look together.

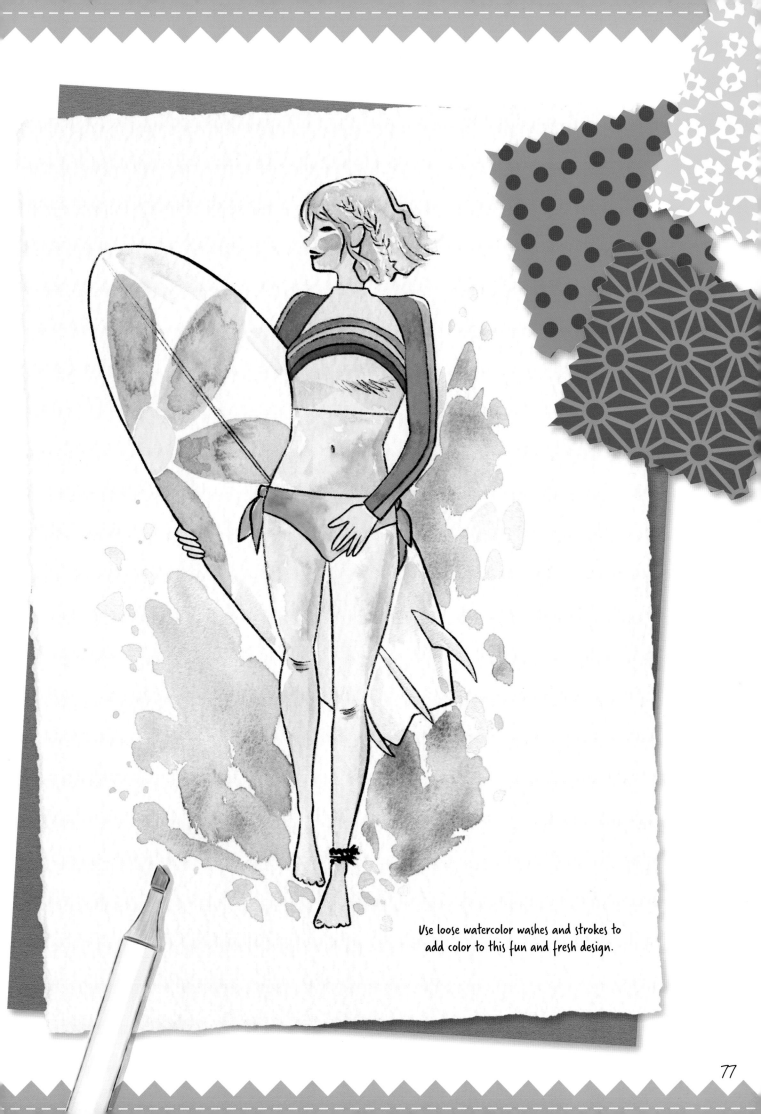

Use loose watercolor washes and strokes to
add color to this fun and fresh design.

After Hours

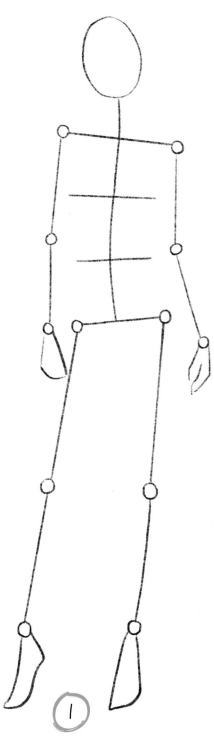

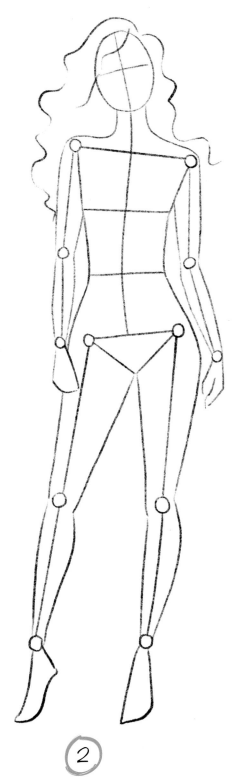

① Model poses that fit the tone and theme of the fashion you are designing are important. This nightclub outfit is symmetrical and will look striking on a model facing forward with squared shoulders.

② Fill out the form and add a few pencil strokes that indicate a hairstyle that matches the outfit.

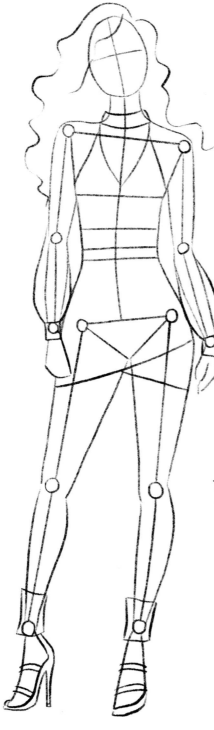

Tip! ✂

Fashion is your opportunity to experiment
and take risks with self-expression,
so don't hold back! The worst that can
happen is that you chuck a crumpled
drawing into the wastebasket. Use your
fashion sketches to indulge every idea and
creative thought you have!

③

Draw the structural outlines of the outfit.
The top includes a sheer overlay with billowy
sleeves. The skirt features a crisscross at the
hemline. Add high-heeled strappy sandals
for a fun, trendy look.

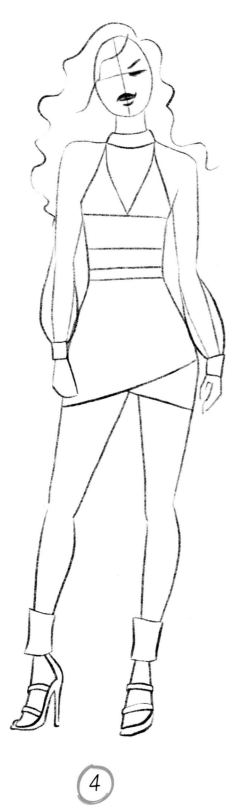

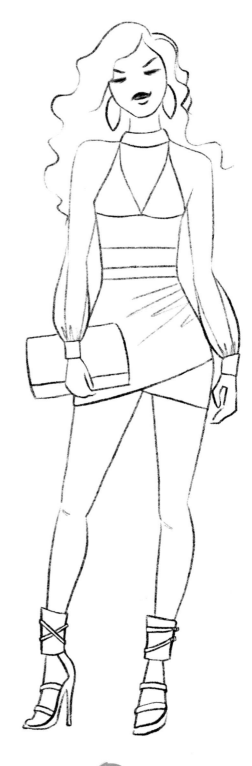

4

Clean up your illustration by erasing any old sketch lines. Suggest a bold lip color for this nighttime look.

5

Add a few final details. Remember that simple shapes often speak for themselves and don't need too many fussy extras. In this case, a shirred hip on the skirt, chunky earring and bag, plus ankle straps on the shoes are all that is needed.

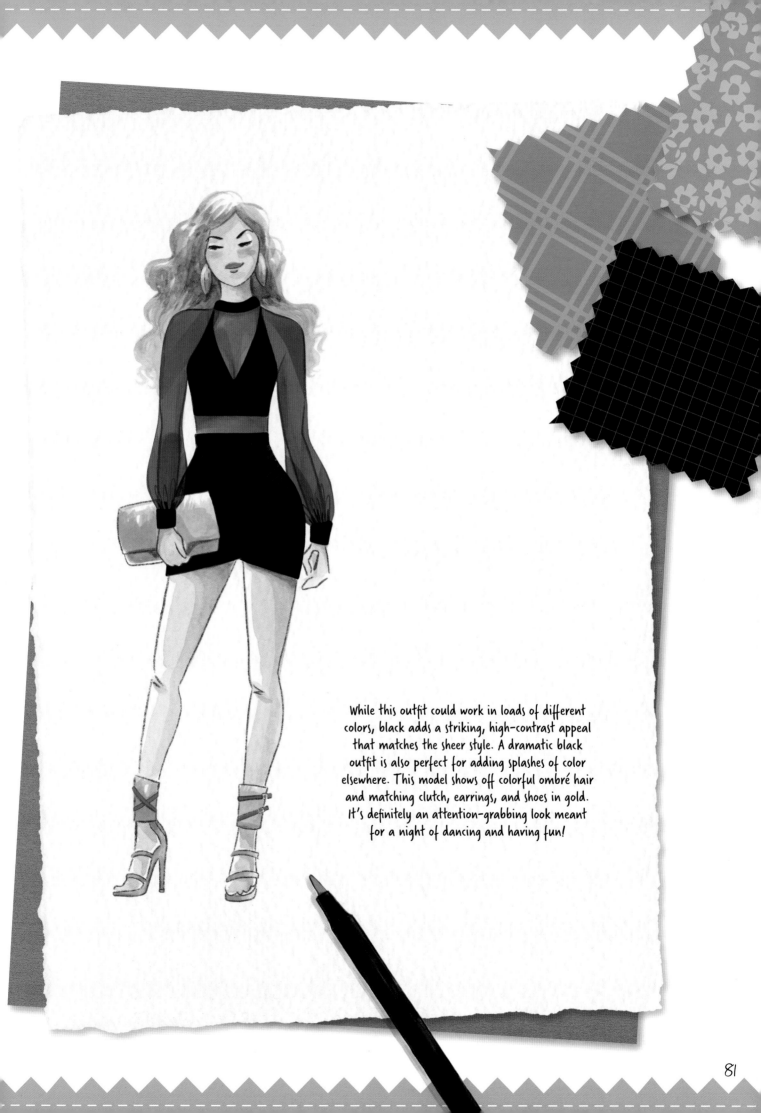

While this outfit could work in loads of different colors, black adds a striking, high-contrast appeal that matches the sheer style. A dramatic black outfit is also perfect for adding splashes of color elsewhere. This model shows off colorful ombré hair and matching clutch, earrings, and shoes in gold. It's definitely an attention-grabbing look meant for a night of dancing and having fun!

Rock-n-Roll

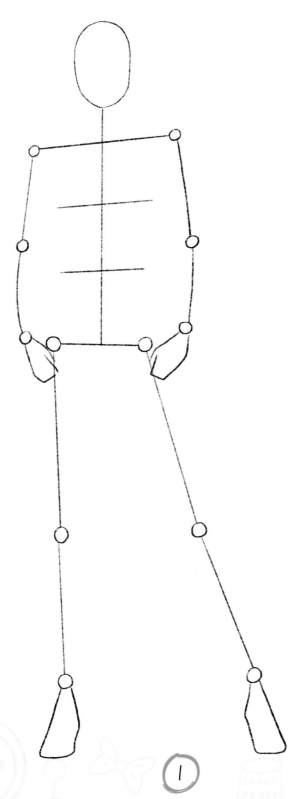

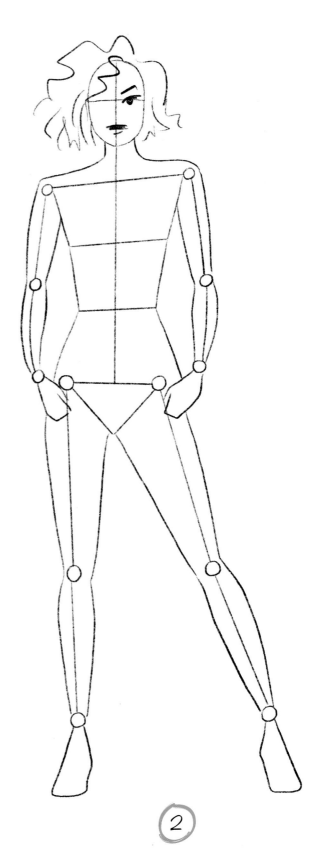

①

Start with a stick figure, experimenting with poses that match this design. If you like, work from a reference photo that shows a strong pose for this look.

②

Fill in the form, and a simple eye, lip, and scribble of hair.

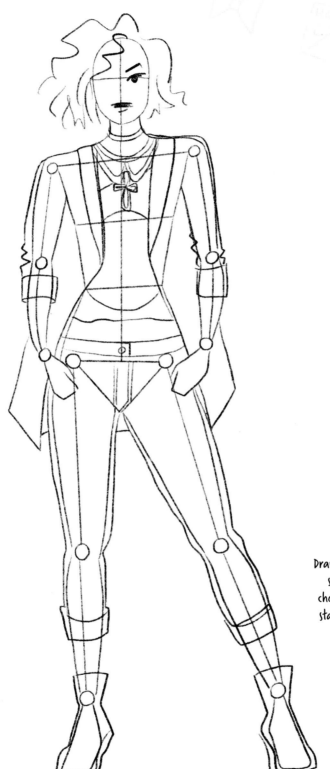

3

Draw the clothing using simple lines, indicating shape, volume, hemlines, and layering. A choker necklace is a huge part of this fashion statement, so include it in this step—or add any other accessories that you'd like.

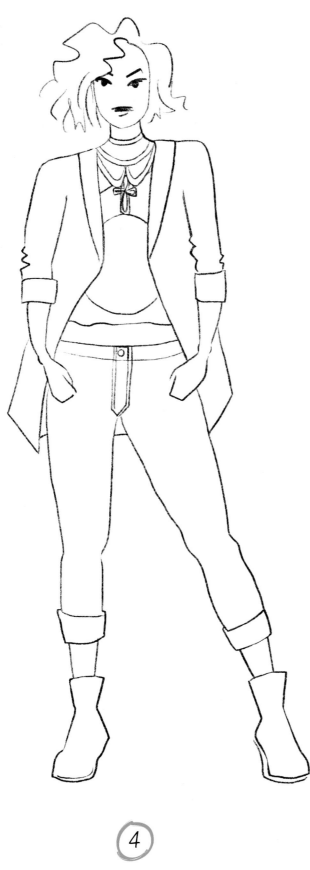

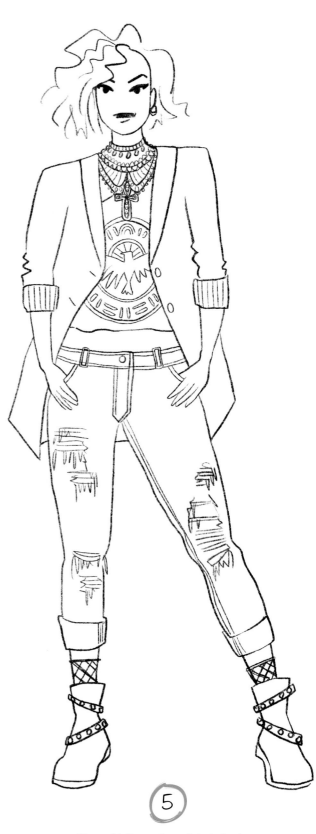

④

Erase any stray lines and
structural lines.

⑤

Now add the rocking details to show
your style! Add rips to the jeans,
studded straps to the shoes, fishnet
socks, and a graphic tank top.

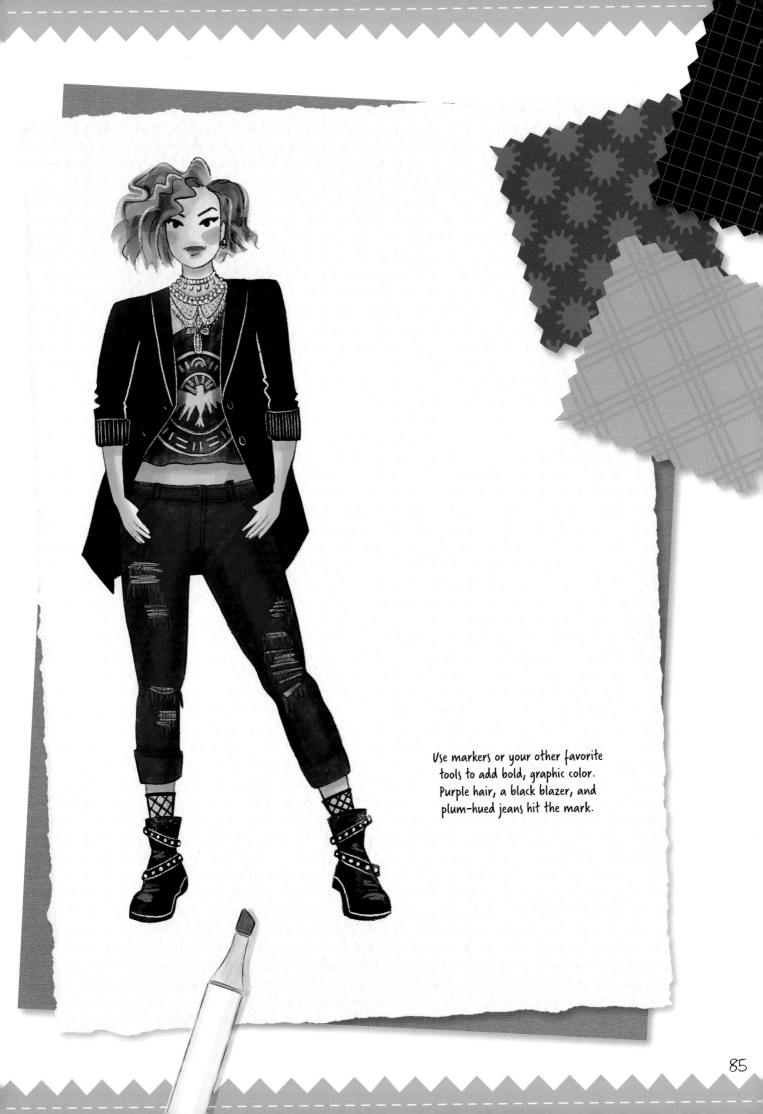

Use markers or your other favorite tools to add bold, graphic color. Purple hair, a black blazer, and plum-hued jeans hit the mark.

On the Slopes

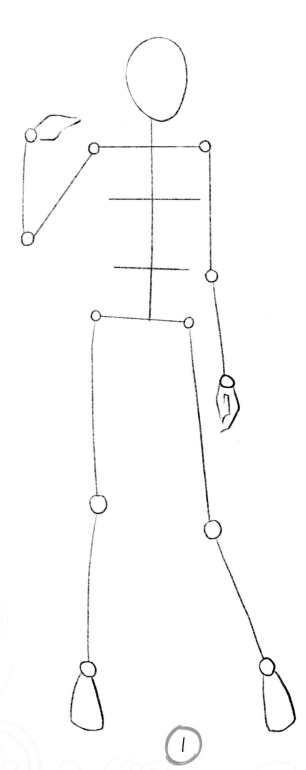

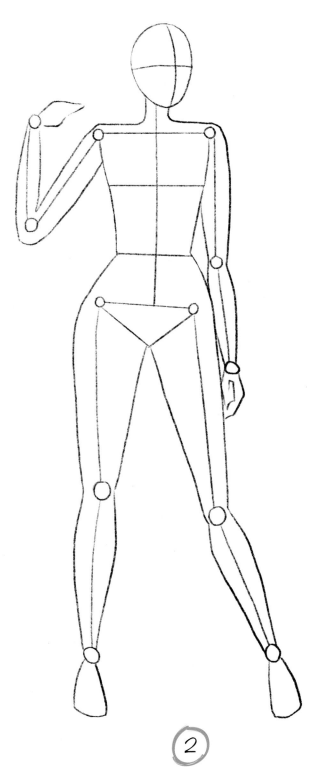

1

Begin with a stick figure that
establishes a pose with good
proportion and balance.

2

Build out the form, and then add
a vertical centerline and horizontal
eyeline to the head.

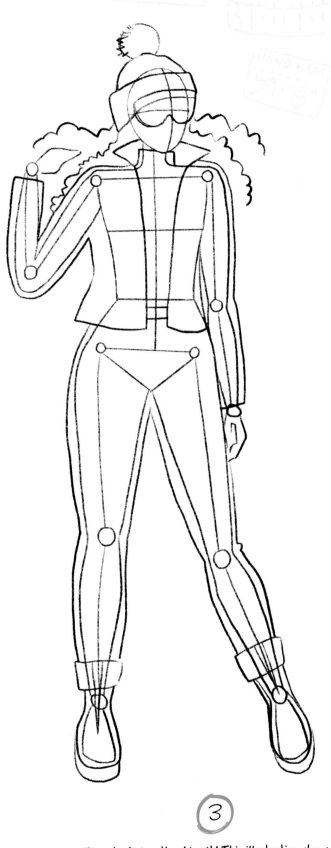

③

Time to design the ski suit! This illustration shows the
silhouette of a retro-inspired two-piece ensemble with
faux fur-trimmed boots and a pom-pom knitted cap.
Don't forget the goggles or fashionable sunglasses,
which are a big part of the finished look.

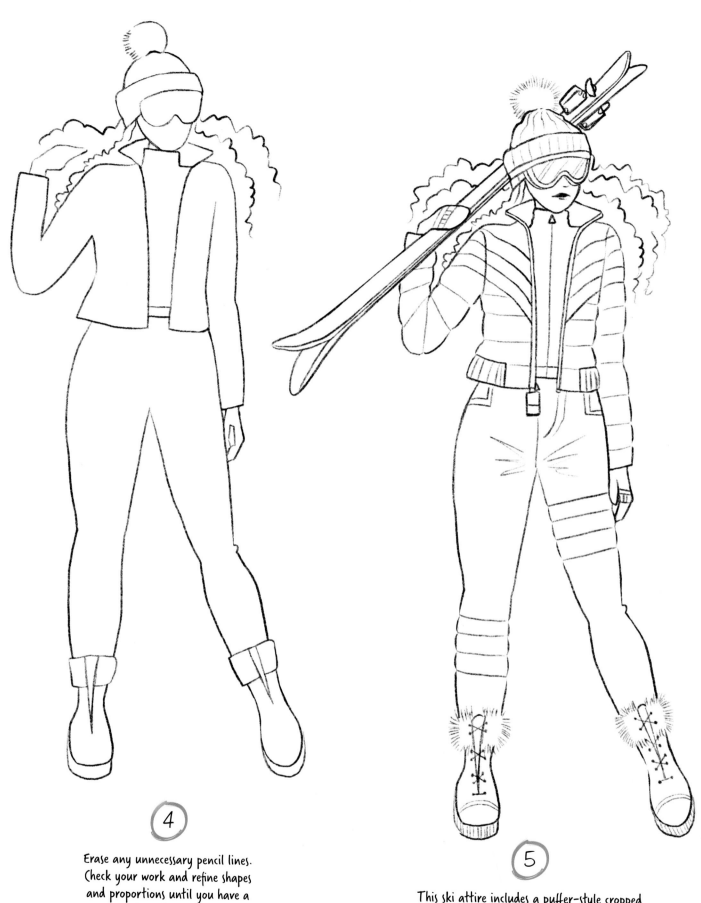

④

Erase any unnecessary pencil lines.
Check your work and refine shapes
and proportions until you have a
clean drawing.

⑤

This ski attire includes a puffer-style cropped
jacket with circa 1970s-inspired stripes and
coordinating ski pants. Add matching mittens,
ribbed trim at the waist, a zipper on the fleece,
and some skis to make it legit.

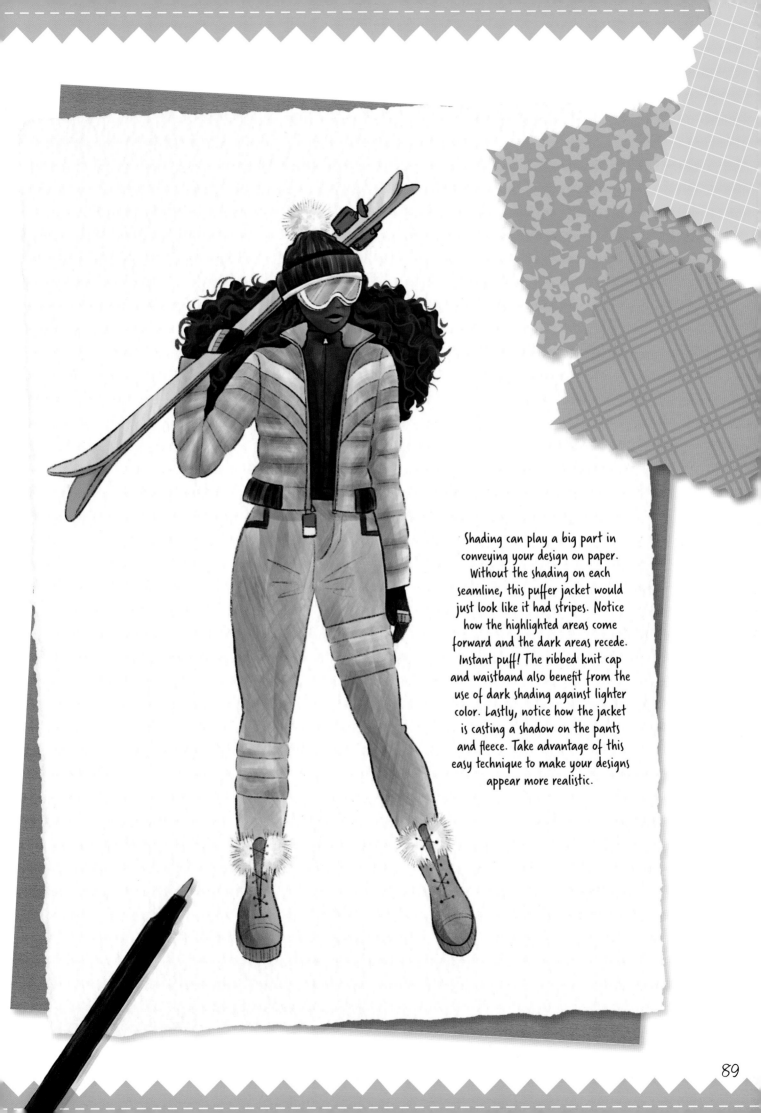

Shading can play a big part in conveying your design on paper. Without the shading on each seamline, this puffer jacket would just look like it had stripes. Notice how the highlighted areas come forward and the dark areas recede. Instant puff! The ribbed knit cap and waistband also benefit from the use of dark shading against lighter color. Lastly, notice how the jacket is casting a shadow on the pants and fleece. Take advantage of this easy technique to make your designs appear more realistic.

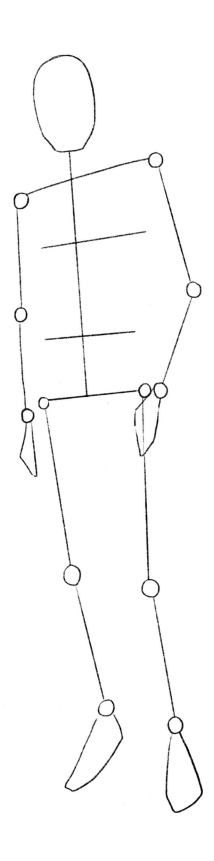

1

Sketch this pose using basic lines
and circles at each joint.

Tip!

If you are designing an outfit for yourself,
consider taking some full-length selfies for
a visual reference from which to sketch.

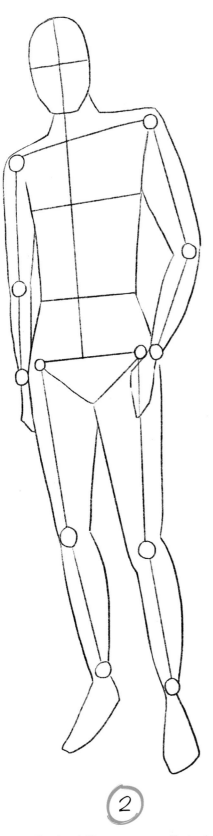

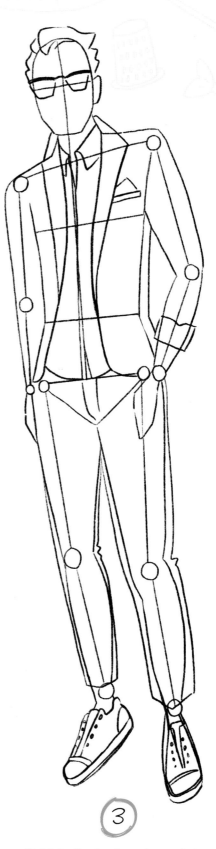

2

Build out the figure. Draw the limbs
according to your preference.

3

Sketch in the structure of your design.
In this case, it's a tailored jacket
combined with a casual button-down
shirt and ankle-length chinos.

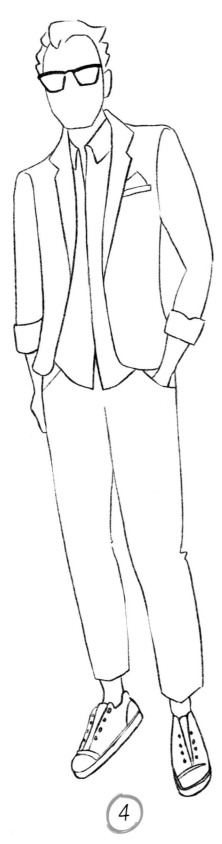

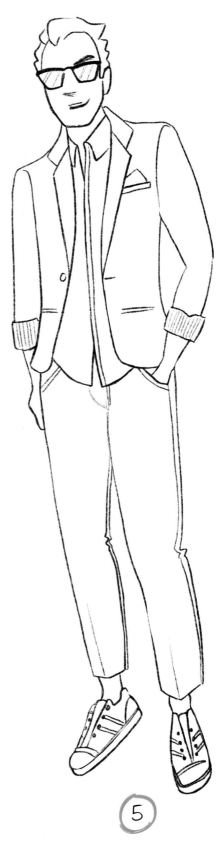

(4)

Use a kneaded eraser to clean up old sketch lines. Refine the remaining lines and curves to make sure you are happy with the proportions.

(5)

Have fun with the details! Add stripes, polka dots, a jacket lining at the cuffs, and a trendy design on the sneakers. Don't forget functional touches like pockets and closures.

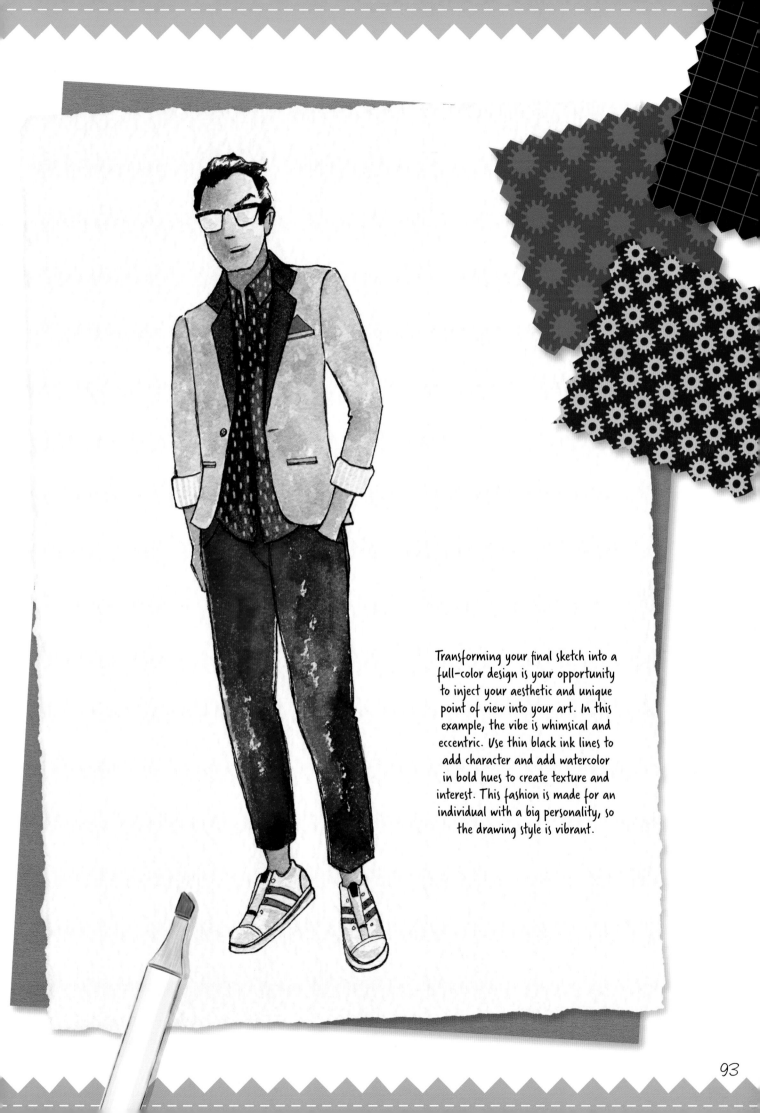

Transforming your final sketch into a full-color design is your opportunity to inject your aesthetic and unique point of view into your art. In this example, the vibe is whimsical and eccentric. Use thin black ink lines to add character and add watercolor in bold hues to create texture and interest. This fashion is made for an individual with a big personality, so the drawing style is vibrant.

Tennis Pro

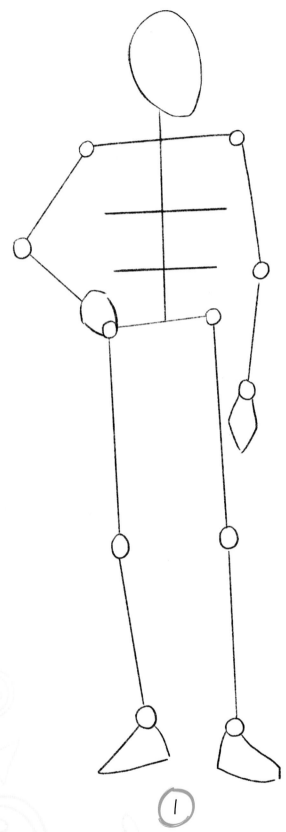

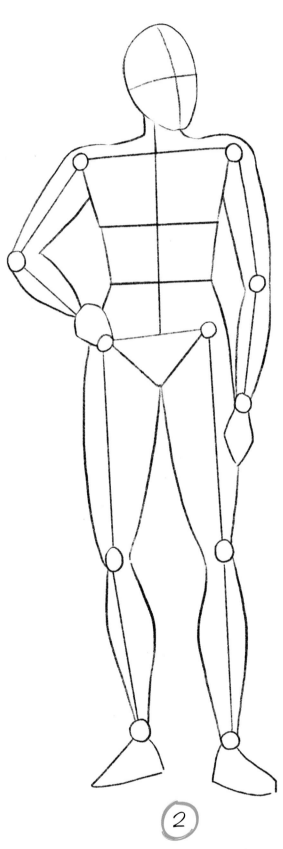

Begin by drawing a strong stance. Use simple horizontal lines to stack the shoulders, chest, waist, and hips. From there, add limbs with circles at each joint and simple shapes for the hands and feet.

Begin adding volume to the figure noting this athlete's strong, solid limbs and broad shoulders. Add a midline and eyeline to the face.

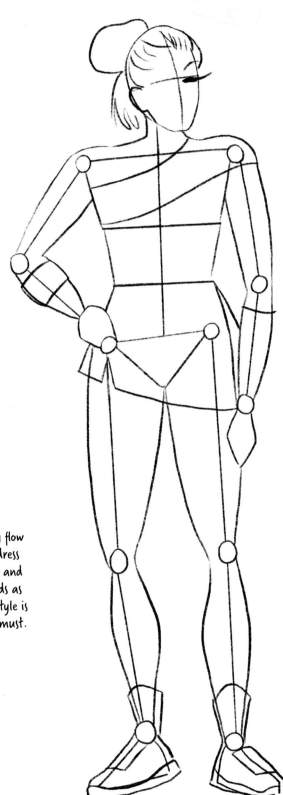

③

Design the outfit! You can let your creativity flow even with something as simple as a tennis dress or other athletic wear. An asymmetric hem and one-shoulder design with color blocking reads as confident and capable. The pulled back hairstyle is suited to the sport, and athletic shoes are a must.

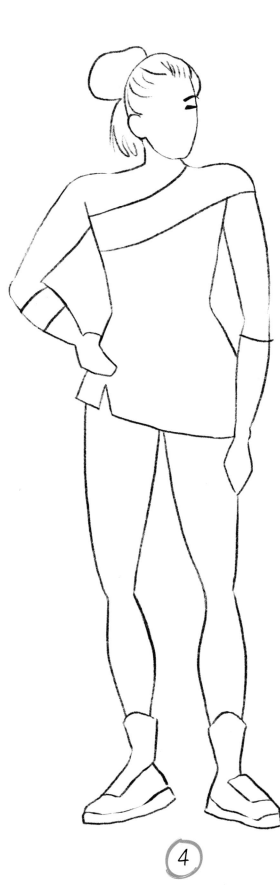

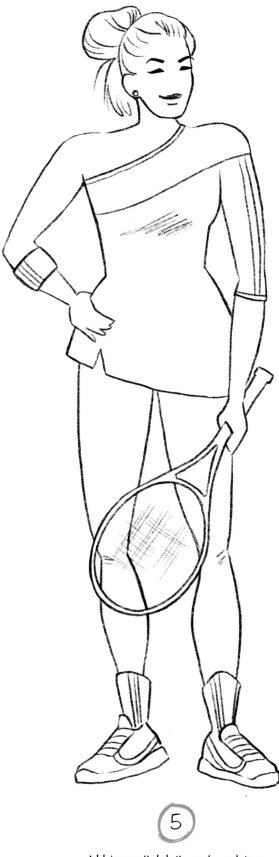

④

Erase old sketch lines and refine the
drawing until it is well-balanced.

⑤

Add in small details, such as stripes,
stitching lines, a coordinating sweatband
on one arm, and socks for the win. The
tennis racquet completes the look!

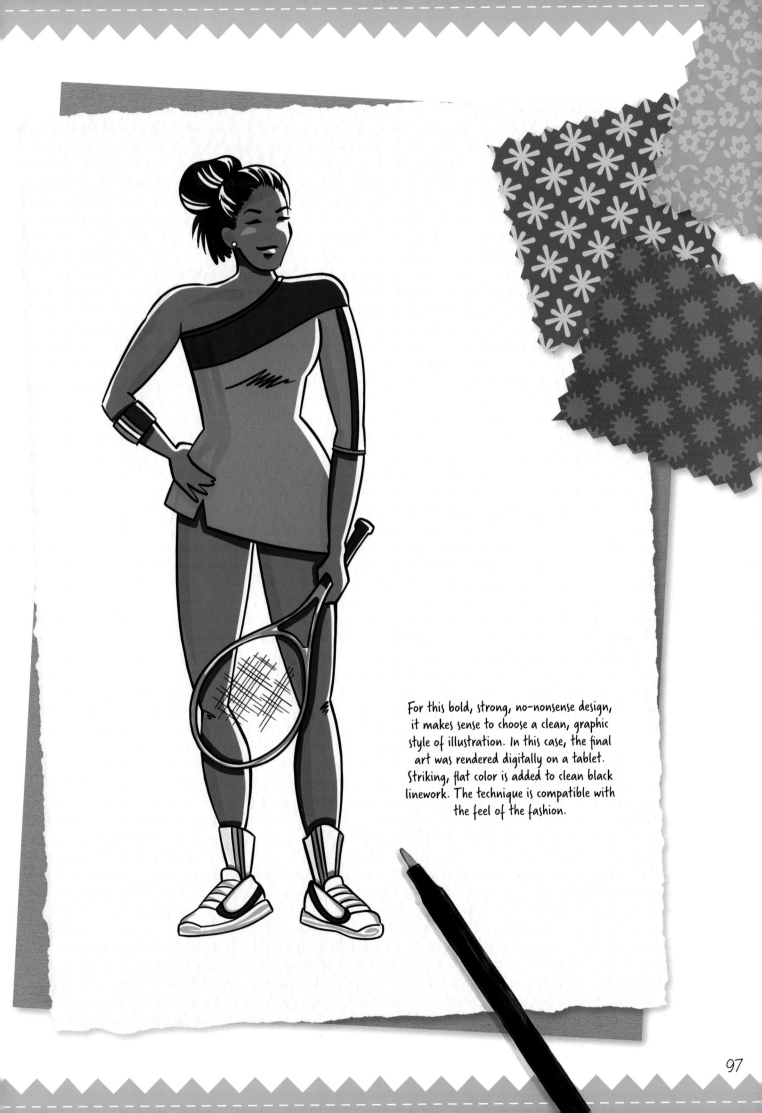

For this bold, strong, no-nonsense design, it makes sense to choose a clean, graphic style of illustration. In this case, the final art was rendered digitally on a tablet. Striking, flat color is added to clean black linework. The technique is compatible with the feel of the fashion.

Boho Chic

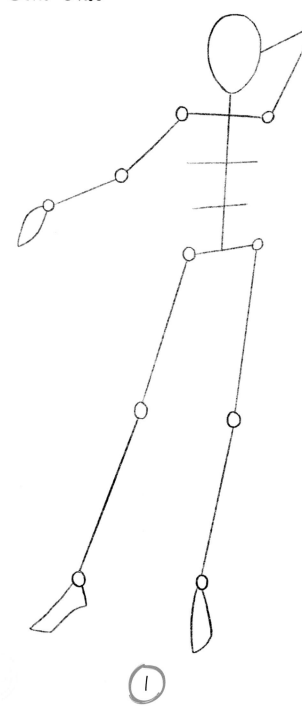

①

Draw a figure in a pose that suits your design idea. In this case, a carefree pose is perfect for a free-spirited festival goer.

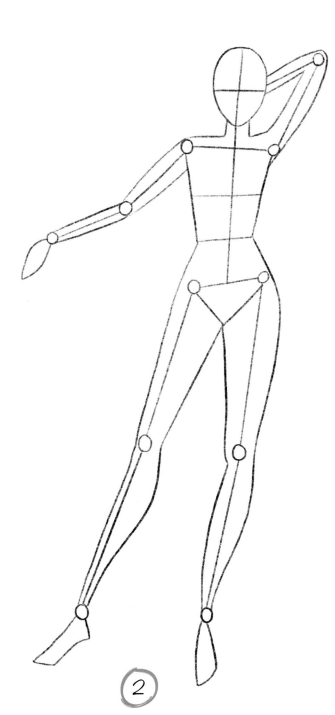

②

Fill in the stick form by outlining the structure. Create curves to suit the body type, and add a midline and eyeline to the face.

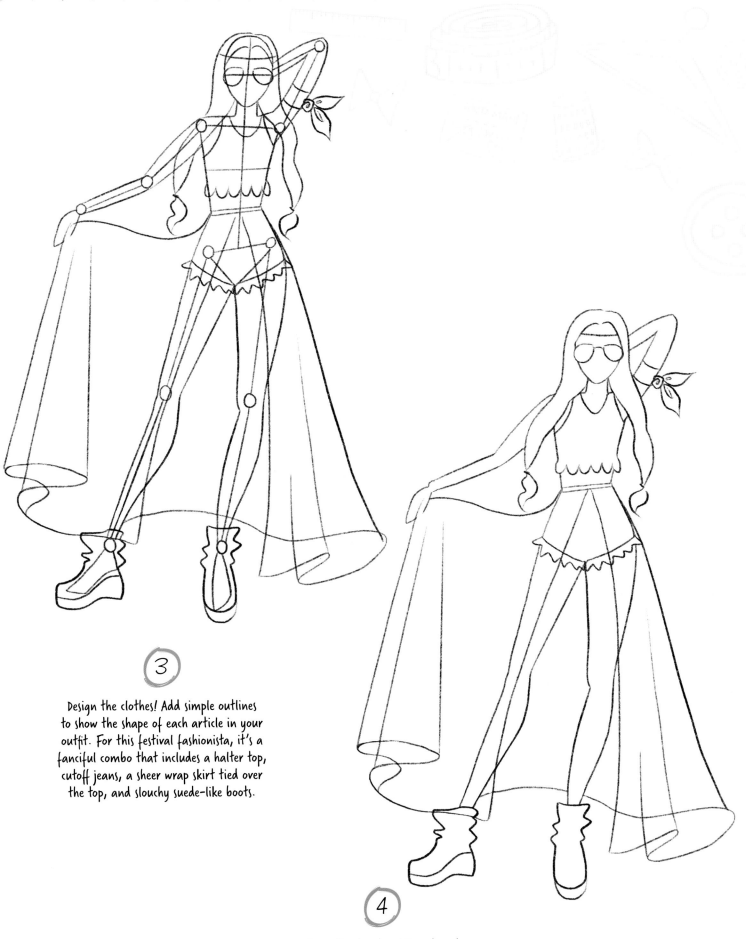

③

Design the clothes! Add simple outlines
to show the shape of each article in your
outfit. For this festival fashionista, it's a
fanciful combo that includes a halter top,
cutoff jeans, a sheer wrap skirt tied over
the top, and slouchy suede-like boots.

④

Erase the structural lines to get
a clean version of your design.

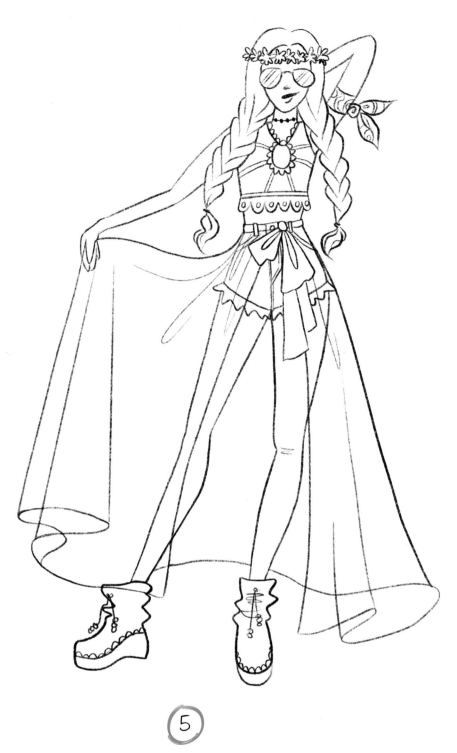

⑤

Embellish and add details! This outfit is a more-
is-more situation full of fun. Add beads on the
boots and a fun floral pattern on the skirt. Sketch
a daisy-chain headband, aviators, and a printed
scarf tied onto one arm. Long braided pigtails
complete this look.

This boho beauty deserves an illustration style to match her personality. Outlining the figure in burnt sienna colored pencil adds an earthy effect. Use masking fluid to "paint" the flower pattern on the skirt. Next, add sheer watercolor washes to give the skirt a romantic, ethereal feel. Once the paint dries, gently rub off the masking fluid to reveal "flower" voids that you can then paint in vibrant shades of red and pink. Add a few pale background details to give your figure a sense of place—an art technique commonly used by designers.

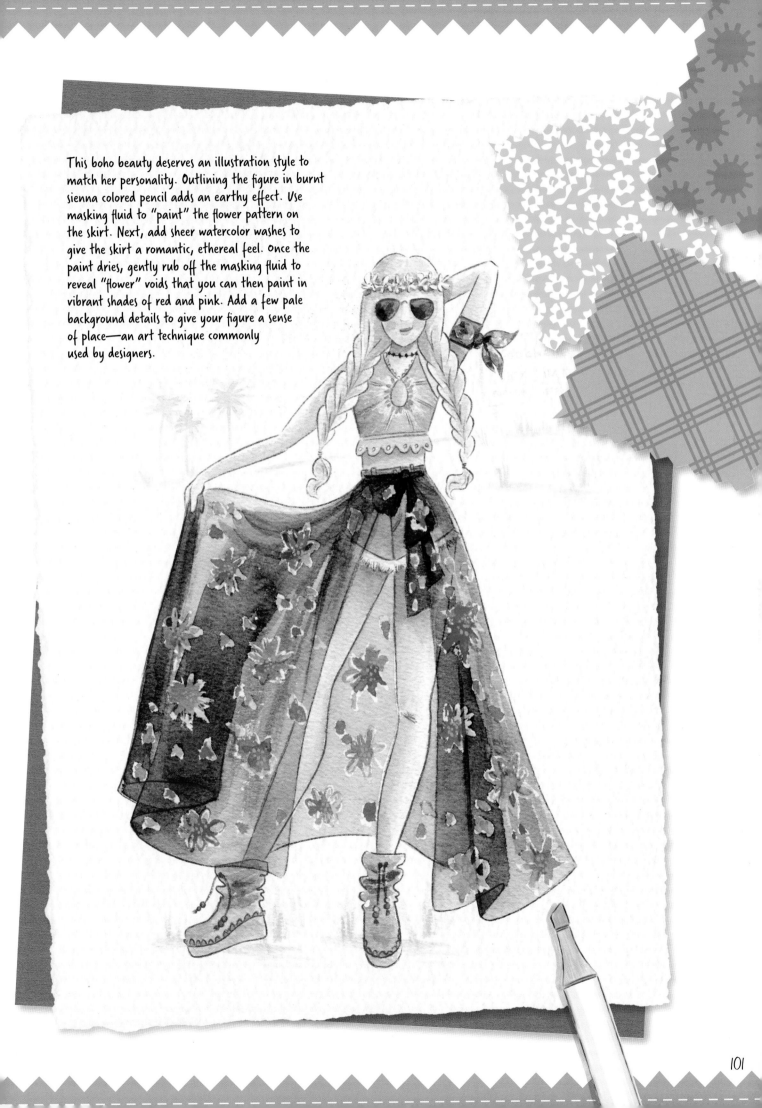

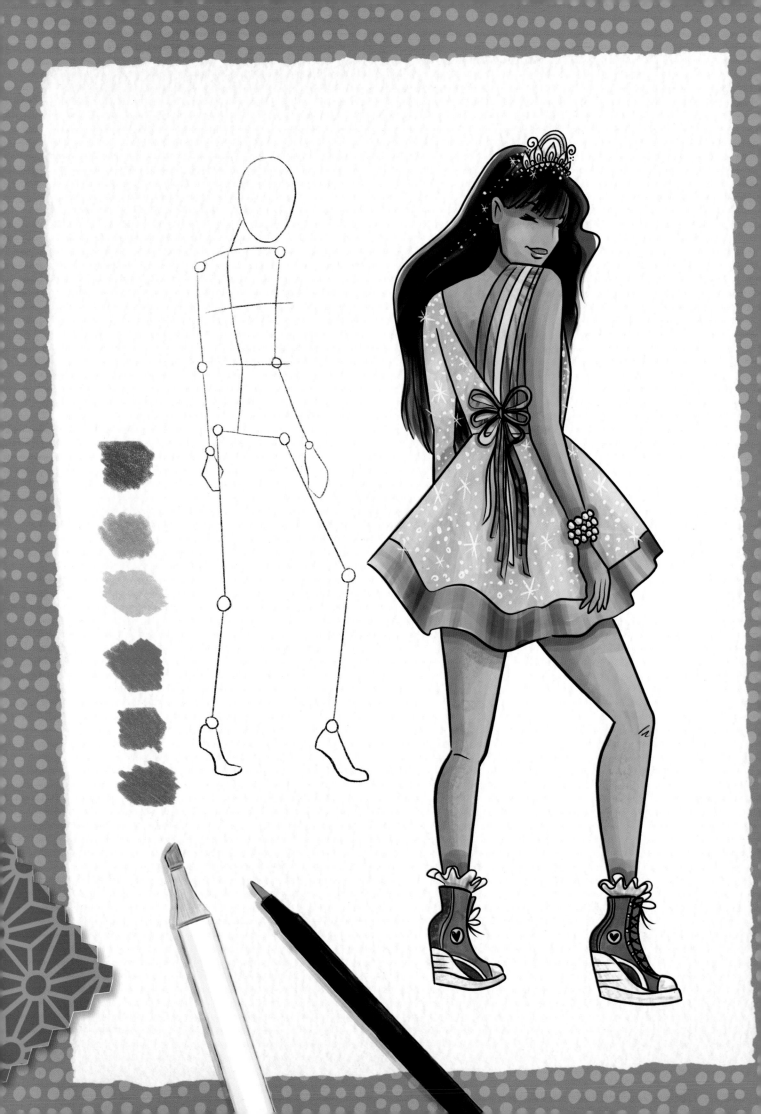

Special Occasions: Step-by-Step Projects

Formal (or Not-so-Formal) Wear

We've established that fashion is an integral part of our daily lives and that there is an outfit for each and every activity. But the most iconic outfits start in the world of haute couture: custom, high-end, one-of-a-kind fashions created by famous designers. From the ostentatious fashions worn by Lady Gaga to the classic gowns gracing Oprah Winfrey, designing for special occasions is where the glamour begins! Borrow one or more ideas from these fashion-forward designs to create your own unique line of formal wear!

Red Carpet Glam

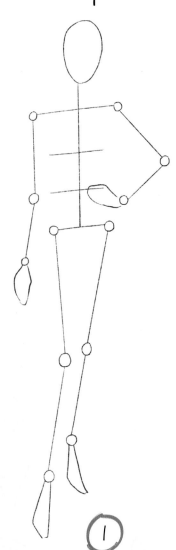

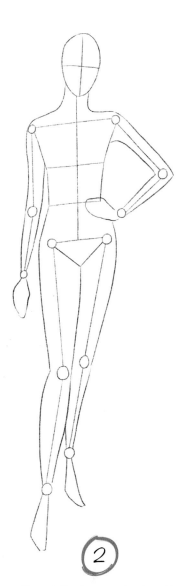

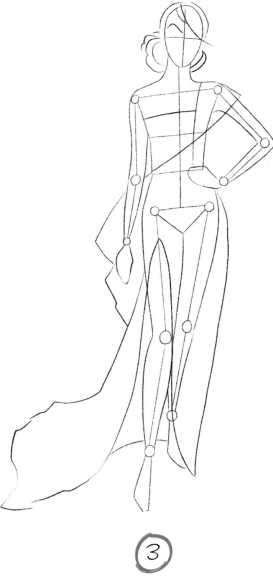

1. Start with a stick figure.

2. Fill out the form, indicating the neck, arms, legs, and torso. Add a centerline to the face and a horizontal eyeline.

3. Sketch in the elemental design features of the gown. Think about neckline, skirt shape, fullness, and angles while you draw. Sketch a hairstyle that complements the style of the dress.

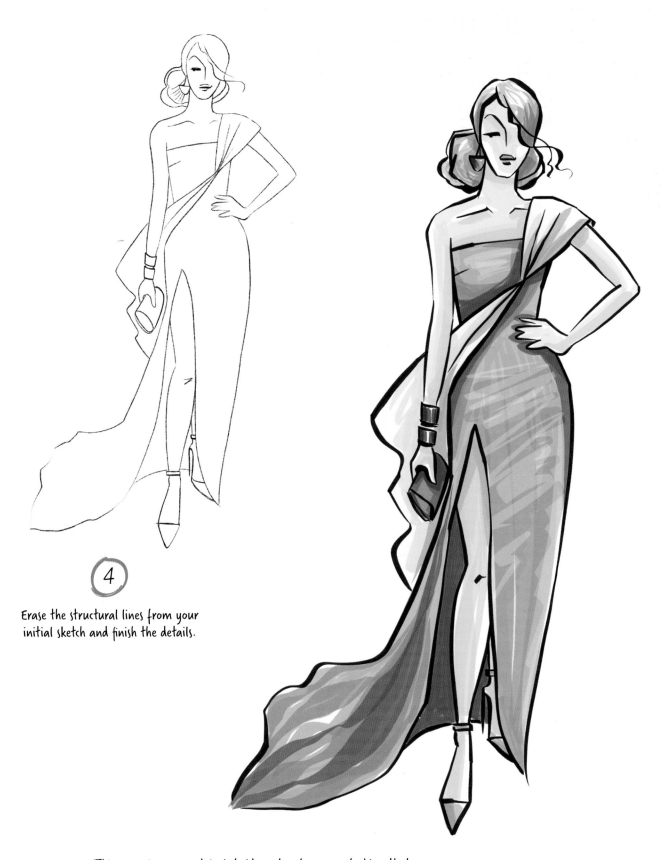

④

Erase the structural lines from your
initial sketch and finish the details.

This gown is asymmetrical, bold, and unfussy—a fashion that
projects confidence! A strong black outline emphasizes the shape
of the gown, while scribbly strokes of color indicate texture and
shine. Streaky fills of lighter color create highlights and give the
illustration a studio sketch vibe.

Classic Ball Gown

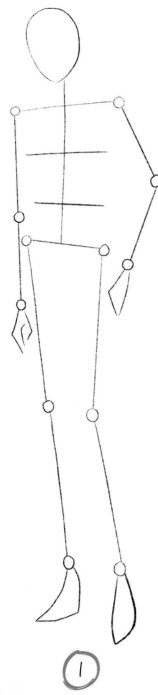

1

Start with a stick figure in
a classic pose.

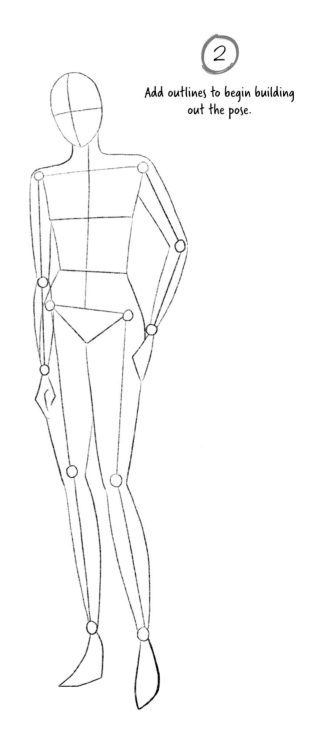

2

Add outlines to begin building
out the pose.

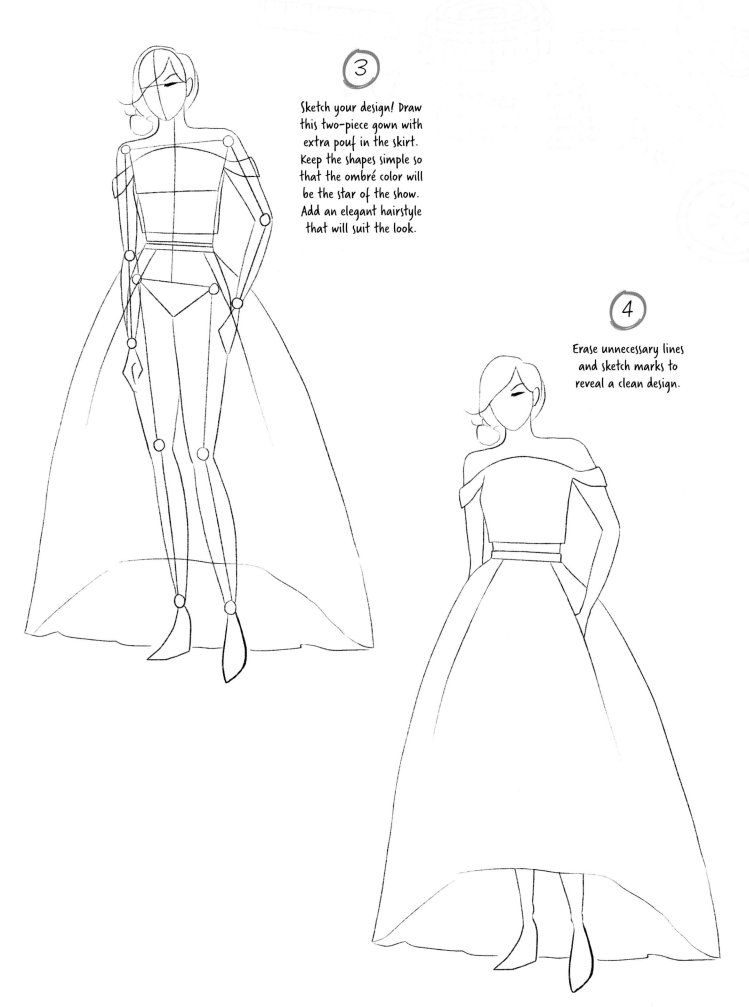

③

Sketch your design! Draw this two-piece gown with extra pouf in the skirt. Keep the shapes simple so that the ombré color will be the star of the show. Add an elegant hairstyle that will suit the look.

④

Erase unnecessary lines and sketch marks to reveal a clean design.

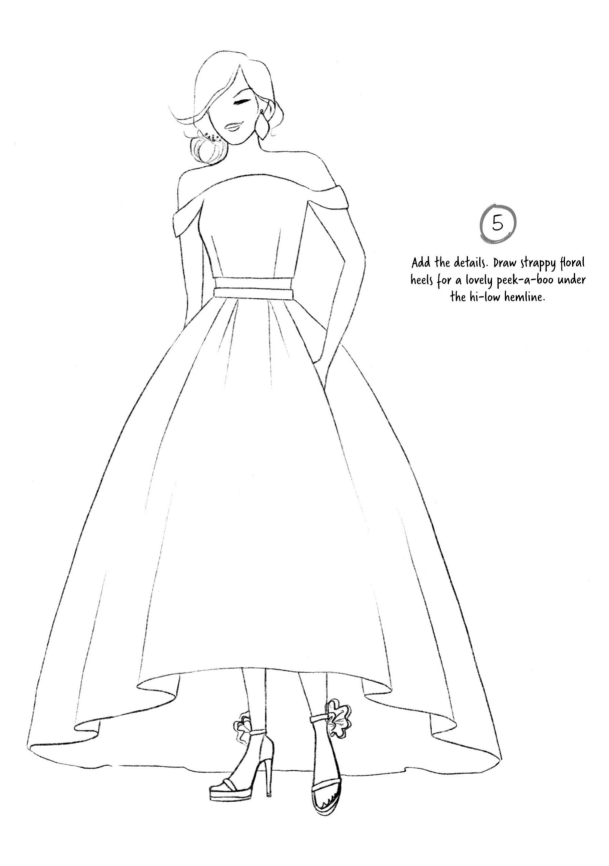

⑤

Add the details. Draw strappy floral heels for a lovely peek-a-boo under the hi-low hemline.

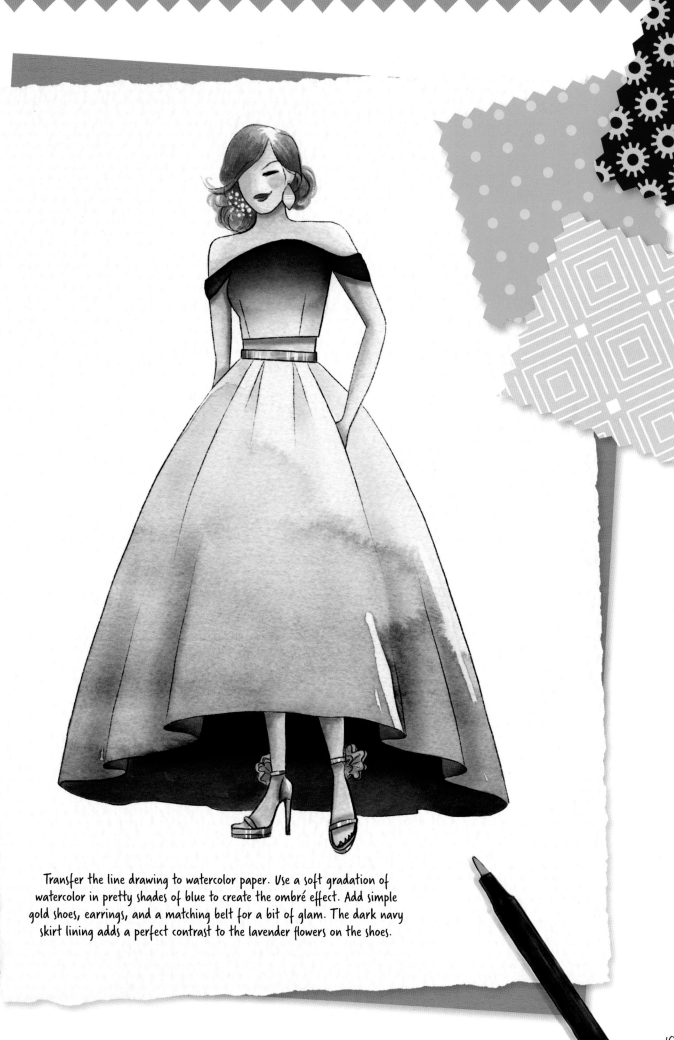

Transfer the line drawing to watercolor paper. Use a soft gradation of watercolor in pretty shades of blue to create the ombré effect. Add simple gold shoes, earrings, and a matching belt for a bit of glam. The dark navy skirt lining adds a perfect contrast to the lavender flowers on the shoes.

Floral Tux

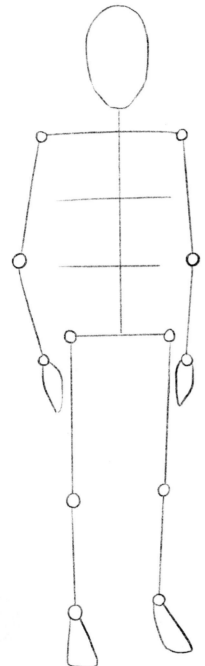

① Start with a stick figure in a simple pose. Use an oval for the head; then stack horizontal lines for the shoulders, chest, waist, and hips.

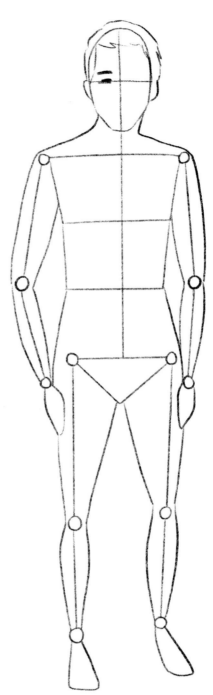

② Add weight to the figure by outlining the structure. Add a midline and eyeline to the face.

Tip! Formal wear for the prom and other special occasions has evolved over the decades. Gowns can be designed in stunning two-piece coordinates or funky short flounces. Tuxedos can be designed in traditional black or in colorful patterns. The important thing is to have fun and design what makes you feel like your best self!

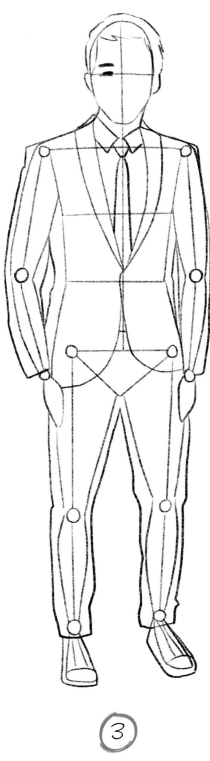

③

Draw the basic structure of the tux.

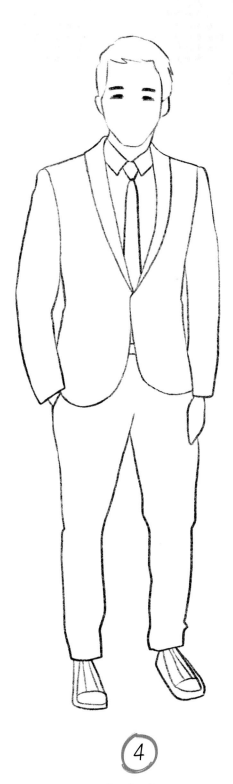

④

Erase the structural lines.

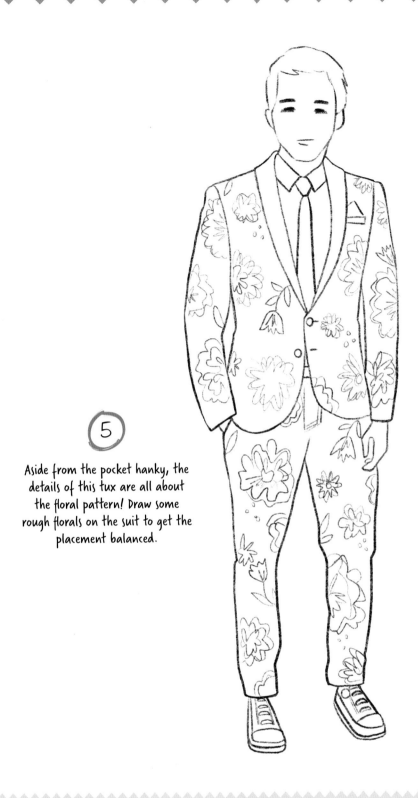

⑤

Aside from the pocket hanky, the details of this tux are all about the floral pattern! Draw some rough florals on the suit to get the placement balanced.

Floral Pattern in Watercolor: Step by Step

1. Place your final sketch on a light box with a fresh sheet of watercolor paper on top. Transfer your design.
2. Use masking fluid to paint the floral shapes on the design. Allow to dry.
3. Select a shade of watercolor for the main suit color—in this case, lavender. Paint the entire suit in your main shade. Don't worry about painting over the floral patterns. The masking fluid will protect those areas. Allow to dry.
4. Gently rub off the masking fluid to reveal clean white areas in the shape of flowers.
5. Select coordinating shades of watercolor; then paint the flowers.

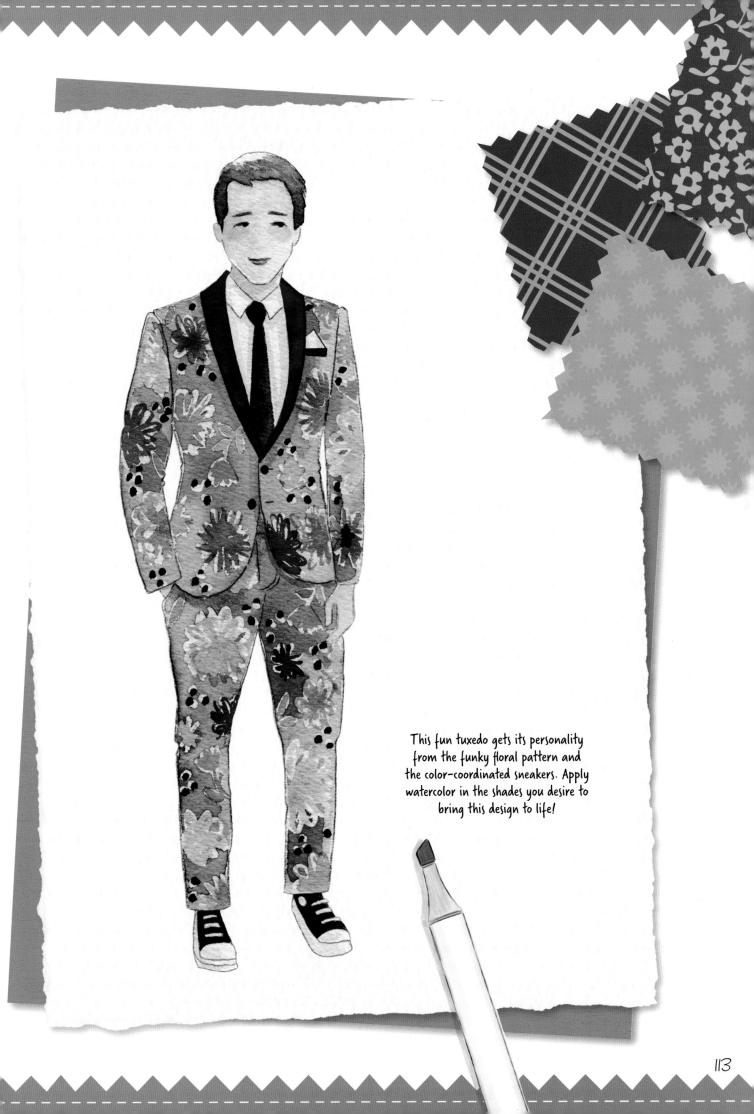

This fun tuxedo gets its personality from the funky floral pattern and the color-coordinated sneakers. Apply watercolor in the shades you desire to bring this design to life!

Flirty & Fun Prom Queen

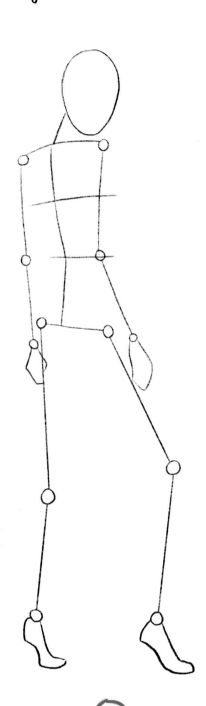

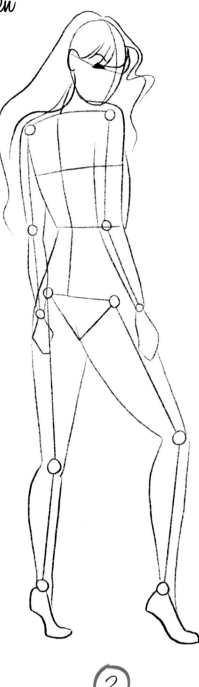

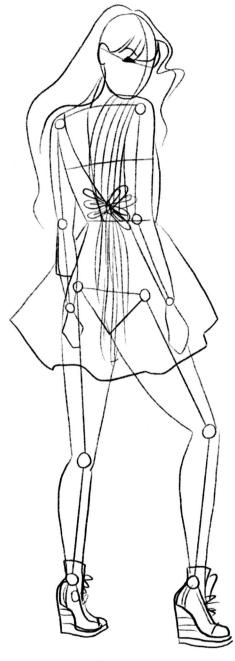

①

Draw a stick figure in a pose that suits your design. This one is a bit trickier because it shows the figure from the back looking over one shoulder. The ribbon shoulder detail with a bow tied in the back at the waist made this pose most desirable. Always consider the strongest design features of your garments, and then create the poses that best showcase these details.

②

Add volume to the form, as well as a midline, eyeline, and hairstyle.

③

Sketch the design! This fancy party dress is colorful and unique with its over-the-shoulder ribbon bow. Wedge sneakers add a playful touch to this already whimsical look.

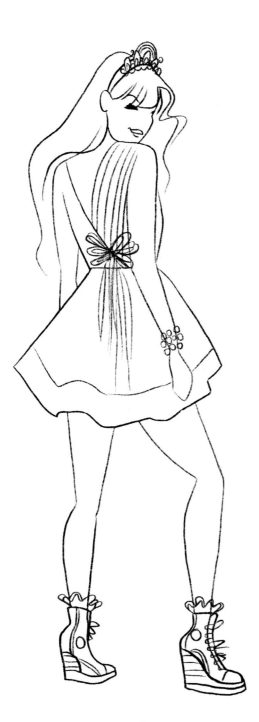

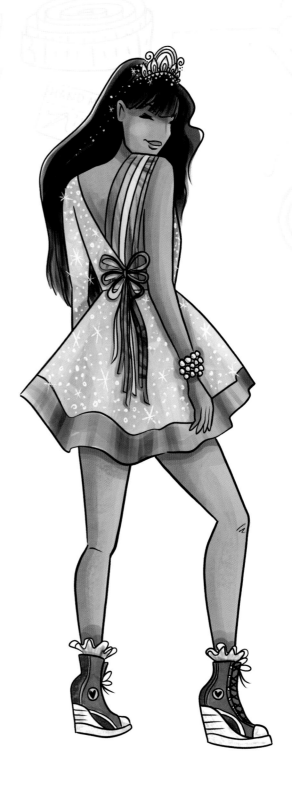

Erase unnecessary sketch marks, and then add accessories, such as a chunky beaded bracelet, ruffled socks, and prom queen-worthy tiara!

This final illustration was colored digitally to capture bright, saturated color and white-on-color sparkles, but you can capture this look just as effectively using markers and ink.

Traditional Tux

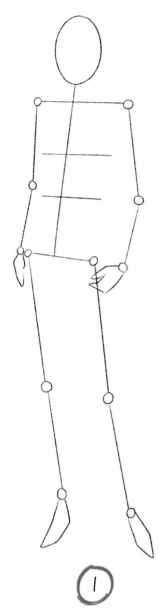

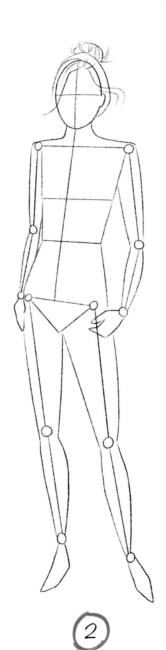

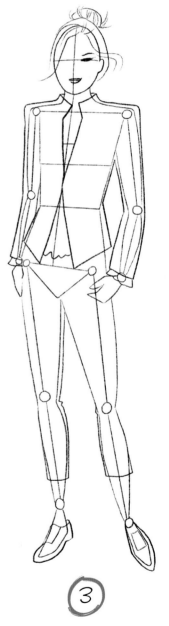

1

Draw a simplified figure in a
suitable pose for your design.

2

Add form to the figure
and a hairstyle.

3

Sketch your design! Pay attention
to proportion and structure.

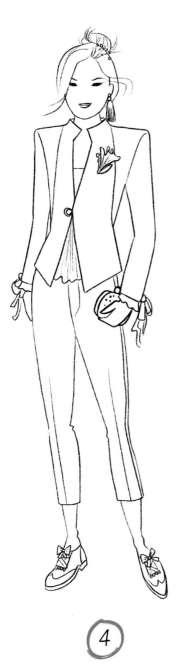

④

Erase old sketch lines, and add
any details that you like!

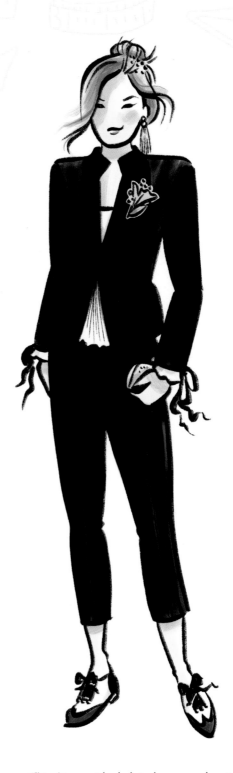

This chic, confident style deserves a drawing
technique with flair. A brush pen drawing
adds great line quality and texture. Add
bold, contrasting blacks digitally or with
heavy marker for extra punch. The pink
hair is just for fun!

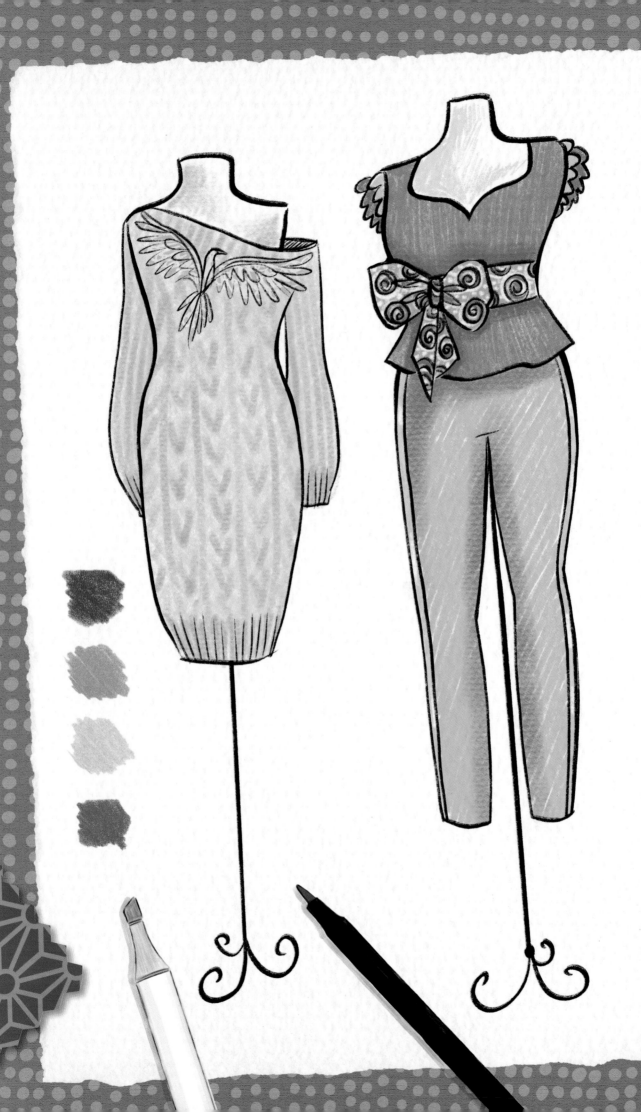

Chapter 6

Design a Line

Mini Collections

Another great way to challenge your design skills is to create three-piece mini collections based on a single word. Building collections forces you to think about different pieces of apparel and ways of dressing. Design loungewear, evening wear, separates, dresses, sportswear, and more. Use one theme word to keep everything consistent.

Idea Factory: Mix & Match

Need a jump-start to get your creative juices flowing? Try these fun exercises for some instant inspiration!

On a piece of paper, fill column A with adjectives, such as colors, textures, feelings, etc. Fill column B with nouns, including people, places, and things.

Column A Examples	Column B Examples
Pink	Rock Star
Fuzzy	Beach
Happy	Leopard
Sparkly	Teenager
Somber	Latte

Now randomly choose one word from column A and match it with one word from column B. Examples: Fuzzy Rock Star, Pink Leopard, or Sparkly Latte.

These may sound like silly combinations but use them to inspire some fashion! Fuzzy Rock Star might inspire an outfit that includes a faux fur jacket with leather pants. Pink Leopard could inspire a pink animal print, but what about a pink silk pajama set with little leopard slippers? Sparkly Latte seems like a great T-shirt graphic, or maybe it's just a sequined skirt in a beautiful creamy golden latte color. Use these kick-starts to rev your design engine, and then run with it!

Collection I: Cupcake

This cupcake-themed collection features bright, cheerful colors and whimsical touches. Slim, cropped pants with a sherbet tuxedo stripe contrast with a feminine blouse with quirky details (Figure 1). A graphic tee featuring a cupcake has a little Peter Pan collar for a prim feel and is paired with a rainbow sprinkle-print midi skirt (Figure 2). Finally, a bright ombré tulle dress is topped with a polka dot blazer (Figure 3). This mini collection has a sweets shop vibe full of fun details!

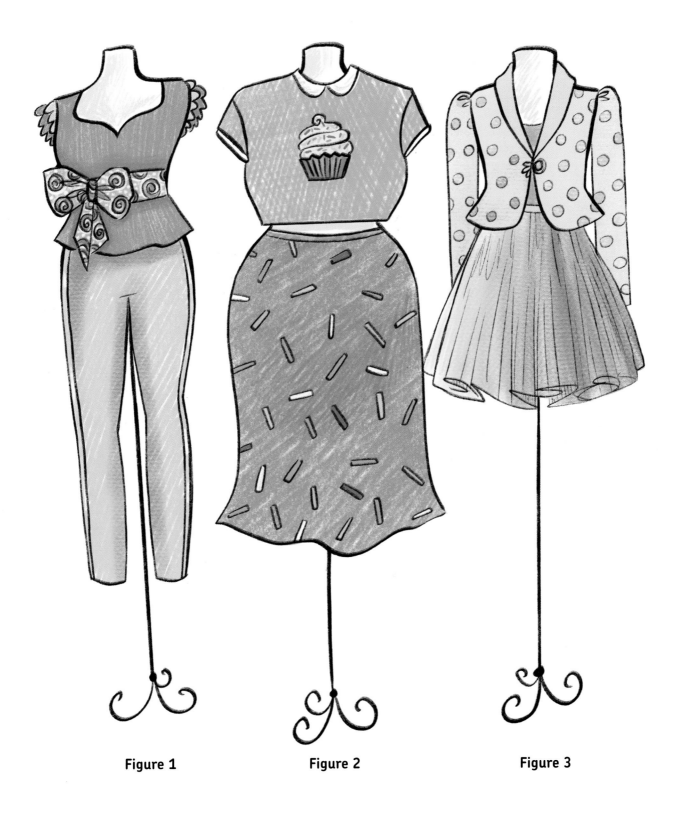

Figure 1 **Figure 2** **Figure 3**

Collection II: Birds of a Feather

This bird-themed collection is sophisticated and stylish. Peacock colors feature in the evening gown along with dramatic feathers and draping on the left shoulder (Figure 1). The second design uses a monochromatic color family. Red, burgundy, and mauve create subtle sophistication with feather detailing on the skirt hem and armholes (Figure 2). The last look is cozy and casual: An oversized cream cable-knit sweater has a winged appliqué across the neckline in a neutral color palette (Figure 3). This collection is like a peek into the closet of a high-society bird lover!

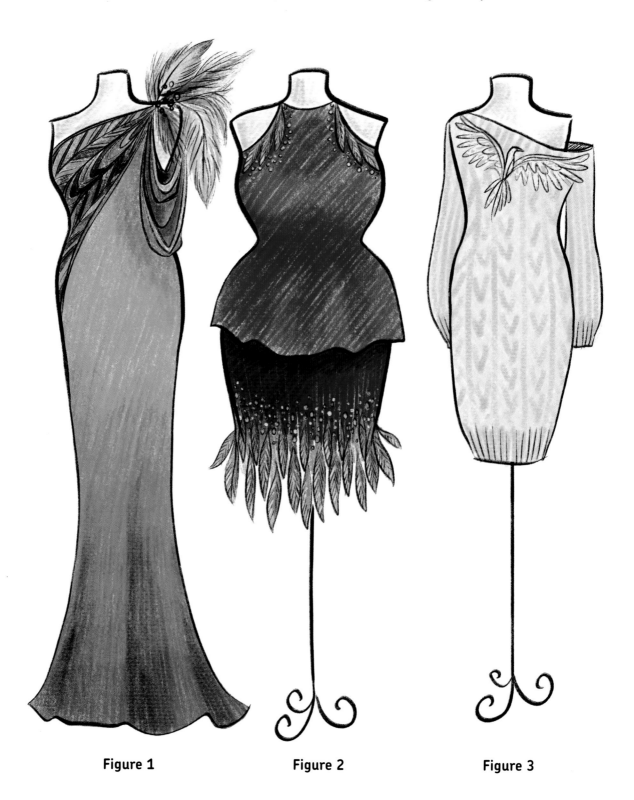

Figure 1 **Figure 2** **Figure 3**

Collection III: Artiste

A mini collection with an Artiste theme is a fun one to imagine. The first design suggests an art studio look. Paint-spattered jeans and a striped boatneck tee feel perfectly casual and creative (Figure 1). A quirky raglan tee and pencil skirt combination is topped with a workroom apron in the second design (Figure 2). Finally, linen balloon pants and a crisp cotton button-down tunic feel effortlessly cool in the third fashion (Figure 3). This collection gives the feel of a capsule wardrobe for some fabulous painter or artisan.

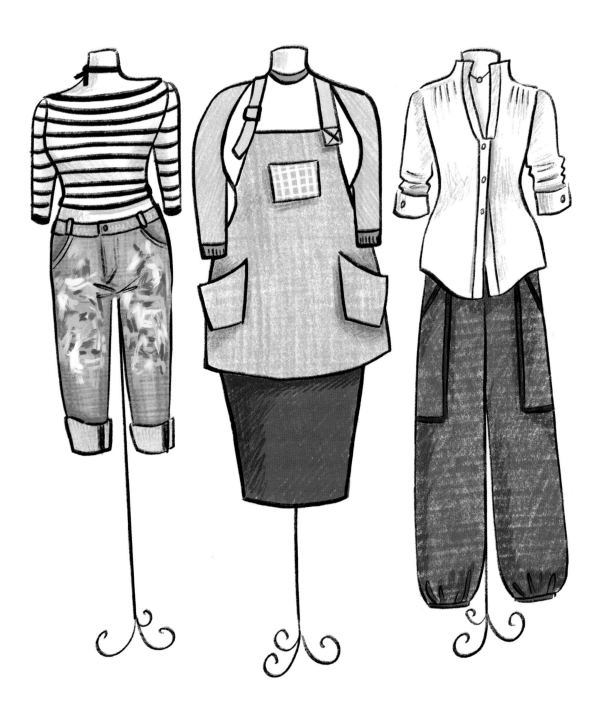

Figure 1 **Figure 2** **Figure 3**

Templates

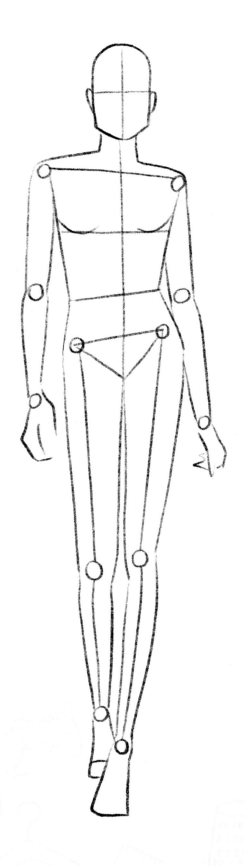
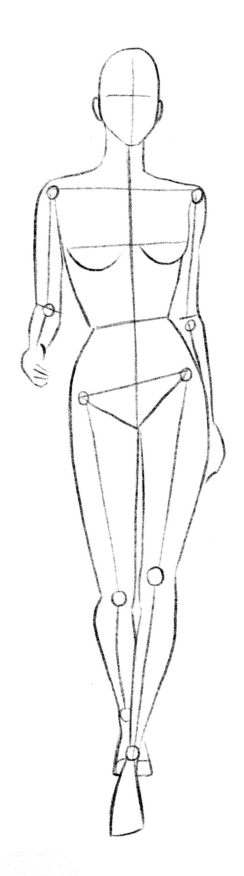

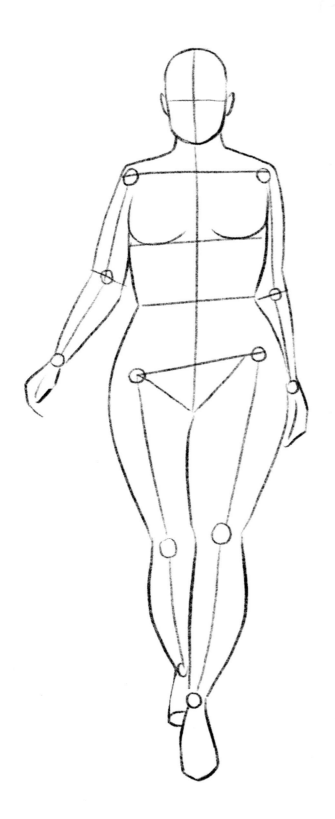
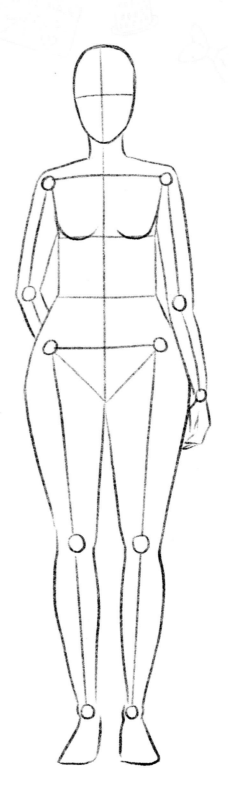

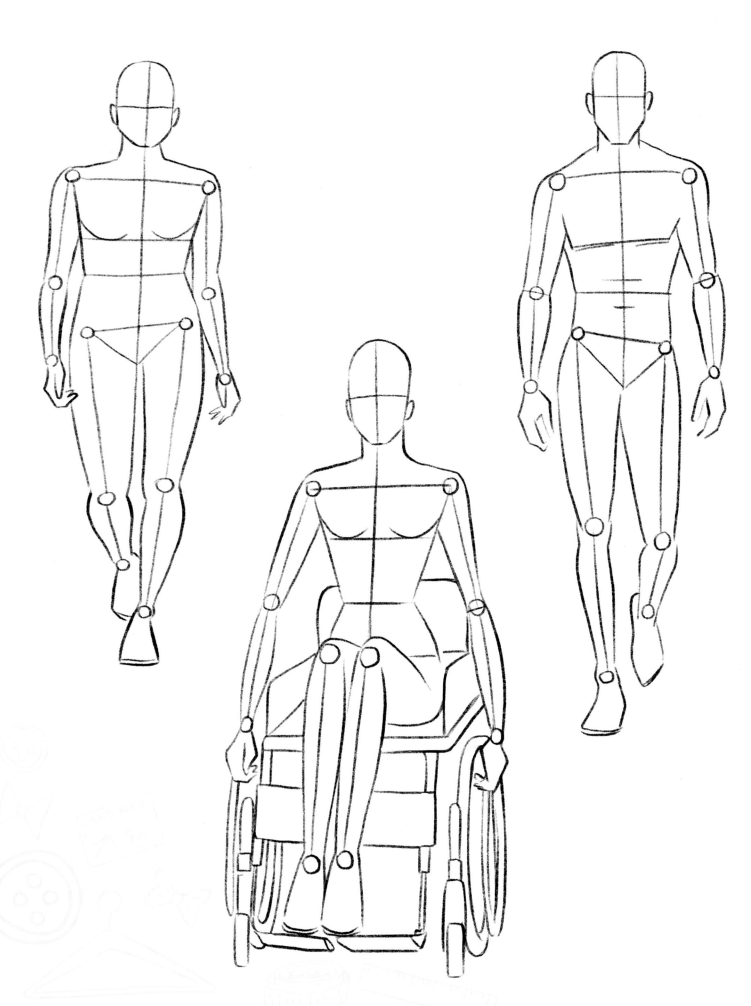

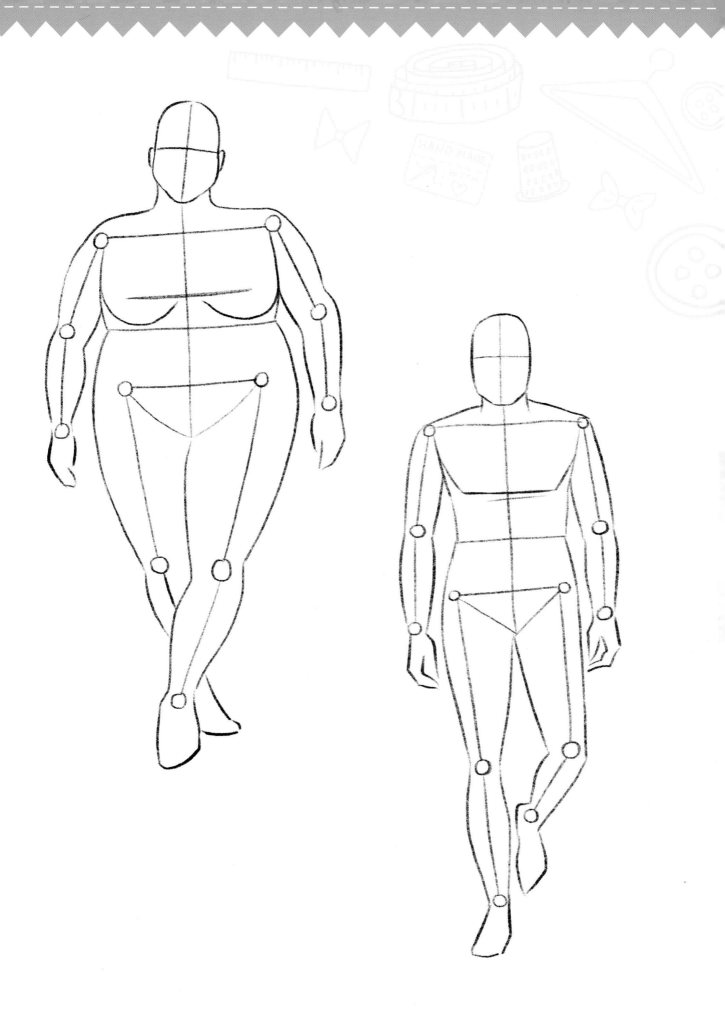

About the Artist

Stephanie Corfee is an artist, designer, and author who works from her home studio in Malvern, Pennsylvania. She and her husband have three sons, plus one brand-new baby girl. Stephanie has written and illustrated several art books and a coloring book, and she licenses her paintings and surface designs for gifts, apparel, and home accessories. Stephanie also teaches online classes available on her website, as well as on Skillshare.com. "The most rewarding part of my job is hearing from students or customers who have used my books. When they tell me they feel encouraged and inspired to create, it makes my whole day." Learn more at www.stephaniecorfee.com.

Also by this Artist

978-1-60058-229-5

978-1-60058-247-9

Q Quarto Knows

Inspiring | Educating | Creating | Entertaining

Visit www.QuartoKnows.com

Walter Foster